PLASTER MOLD AND MODEL MAKING

PLASTER MOLD AND MODEL MAKING

Charles Chaney and Stanley Skee

 VAN NOSTRAND REINHOLD COMPANY

NEW YORK CINCINNATI TORONTO LONDON MELBOURNE

We wish to dedicate this book to the late Cathy Skee, who encouraged us in our efforts, and to Kay Kinney, who first suggested the idea. This dedication would not be complete without mentioning Harry and Sonah Godley, who, by keeping their eyes on the star over the years, provided a ready reference for those of us who were trying to find our own.

Acknowledgments

We wish to thank Vohann of California, Inc., who were so helpful and co-operative in allowing us to use their models and molds for the purposes of this book.

We are indebted to Nancy C. Newman of Van Nostrand Reinhold, whose vision allowed this book to become a reality, and we are particularly grateful to Barbara Klinger, our editor at Van Nostrand Reinhold, whose skills at persistent questioning and whose exceptional understanding acted to make this book even more informative than we had anticipated. Our thanks to her and to all those at Reinhold whose contributions made this book possible.

Van Nostrand Reinhold Company Regional Offices:
New York Cincinnati Chicago Millbrae Dallas
Van Nostrand Reinhold Company International Offices:
London Toronto Melbourne
Copyright © 1973 by Litton Educational Publishing, Inc.
Library of Congress Catalog Card Number 76-39805
ISBN 0 442 21511 8

All photographs and drawings by Charles Chaney

Designed by Visuality
Printed by The Murray Printing Company
Bound by Book Press

Published by Van Nostrand Reinhold Company
450 West 33rd Street, New York, N.Y. 10001

Published simultaneously in Canada by
Van Nostrand Reinhold Company Ltd.

16 15 14 13 12 11 10 9 8 7 6 5 4 3 2 1

Contents

Preface 7

Suggested Reading List 8

1. Plaster — The Material 9

2. Facilities and Tools 13

3. Preparing for the Pour 16

4. Mixing and Pouring Plaster 22

5. The Necessity for Piece Molds 26

6. Making the Piece Mold 38

7. Multiple Mold Requirements: The Block and Case and Production Molds 62

8. Multi-Piece Molds: Problems and Solutions 82

9. Extruding Plaster with the Jack 95

10. Turning Plaster 100

11. Model Problems and Solutions 117

12. General Notes 134

Index 144

Preface

This book is about plaster and how to use it with confidence. Confidence comes with knowledge and it is with this in mind that we present the cumulative experience of our years of working with this superlative material.

This book covers two major aspects of plaster work: the first is the production of a mold from an original model in order to reproduce that model; the second is the production of plaster models from drawn designs. These two aspects have never before been adequately explored nor have their techniques been made easily available to sculptors, teachers, ceramicists, industrial designers and other craftsmen who would benefit from such knowledge. Usually the subject of mold-making is handled as an adjunct to sculpturing and, in this subordinate role, is treated sketchily at best. The subject of forming plaster is usually limited to a discussion of building the form on an armature, applying the plaster with a spatula and hand-carving the hardened form. In this book, however, we will give step-by-step procedures applicable to making a plaster mold of any model, however complex the model may be, and we will describe plaster-forming techniques applicable to making precise, professional models. These mold- and model-making techniques will enable the designer, craftsman, or artist to reproduce his original work accurately and efficiently, and in any quantity, whether his intent is artistic display or commercial production.

Plaster work, like any other craft, is sequential and cumulative; what you learn in chapter one applies in chapter two. Whether the reader is an amateur or a professional, it is best, therefore, to begin at the beginning. Those who have had experience with plaster may find our approach a bit different from their own; those who are new to the game can rely on us to keep them on safe ground as we go along.

7

SUGGESTED READING LIST

Modelled Sculpture and Plaster Casting, Arnold Auerbach.
 New York: Thomas Yoseloff, 1961.

Modelmaking for Industrial Design, Ralph R. Knoblaugh.
 New York: McGraw-Hill, 1958.

The Technique of Casting for Sculpture, John W. Mills.
 New York: Van Nostrand Reinhold, 1967.

1. Plaster-The Material

Plaster is gypsum, a natural mineral found in the earth. Gypsum, or gypsum cement, as it is sometimes called, was first mined for commercial purposes in France during the 1770's, in the Montmartre section of Paris; hence the name "plaster of Paris." Even then it was not a new material; it has been known to man for thousands of years, for it appears in the statuary of ancient Egypt.

Plaster is not found in a ready-to-use state; it must be quarried, crushed, screened, pulverized, and then heated, before it is suitable for casting purposes. This the plaster manufacturer or processor does under closely controlled conditions. The heating process, called "calcining," drives off three-fourths of the plaster's chemically combined water. The residue is then placed in pits and cooled.

This calcining process leaves the plaster in a state of perpetual thirst, which explains its affinity for water. It is this very affinity that is the basis of slip-casting ceramic work the world over.

IMPORTANT PROPERTIES

After the plaster has been carefully ground, calcined, and graded, the white powder that remains has certain important properties. One of these is that the plaster is homogeneous, which means that, when properly mixed with water and allowed to crystallize, plaster will provide us with a solid that has no grain, no soft or hard spots, no lumps or knots; it is therefore a perfect material for receiving our cutting efforts. Whether we carve plaster by hand, turn it on a lathe, or scrape it with a template, we need not be concerned with irregularities of density that are common to other materials such as wood.

Because plaster is homogeneous, we can also depend on its predictability; for a given type and age of plaster, we can mix batch after batch and know that the resultant casts are consistent in their water-absorbing properties. This property assures consistent quality in ceramic products slip-cast in the molds.

COEFFICIENT OF EXPANSION

Plaster has another property which is advantageous: it has a very low coefficient of expansion. This simply means that it does not expand very much when it undergoes its crystallization into a solid form. For most craft purposes, therefore, it is considered one of the most dimensionally stable materials we can find; on the other hand, it *does expand,* minimal as that may be. In fact, one of the first lessons a plaster model-maker learns is that every plaster cast involving close tolerances must take this expansion

into account. So the dimensional stability of plaster can be said to be excellent, *relatively* speaking. Since we know that it is an homogeneous material, we can not only predict that the plaster will expand, we can depend on its percentage of expansion to remain constant. Thus we can plan around the expansion once its extent has been determined.

OTHER CHARACTERISTICS

Compared to other craft materials, plaster ranks as one of the least expensive, thus making for a financially reasonable learning process; we need not fret over unavoidable material wastage. Also, a large percentage of the plaster used in the various steps is discarded, and since it cannot be reclaimed, we are fortunate that this material is so relatively available and inexpensive.

Even though plaster offers all the advantages of low cost, homogeneity, and predictability, there are still two schools of thought regarding its use. One school holds that plaster is, generally speaking, plaster of Paris and that it is a messy, almost uncontrollable but necessary evil which accompanies the art of sculpting. The other holds that it is a useful material in its own right and that it warrants specific study so that the craftsman may handle plaster in a much more satisfactory and assured way. With the latter view in mind, we must first point out that, while all plaster has the same basic characteristics previously described, there are distinct types and grades of plaster, each suited to a particular task at hand, and each differing in certain additional physical properties. These properties include setting time, hardness, strength, water required, workability, fineness, and surface characteristics. Before considering individual types of plaster, we must define these properties further.

SETTING TIME AND PERIOD OF PLASTICITY

The setting time generally means the elapsed time from the moment that the plaster is added to the water until the mix becomes hard enough to handle as a solid mass. During the first portion of the setting time, the plaster is very fluid and can be poured; a little later, it is in a plastic state during which it can be worked with templates and tools.

This later stage in the thickening of the mix is called the "period of plasticity," and its duration varies according to the particular type of plaster being used. This period is one of the most valuable properties to be recognized in a particular plaster, for it is during this period that the gypsum cement can be manipulated to build up models over a framework or can be turned in a box or on the wheel. The evaluation of how a particular material handles during this period can best be learned by mixing actual test batches, following the guidelines for mixing given in this book and the instructions given on the package by the manufacturer.

Important as the period of plasticity is, however, most of the methods described in this book involve using plaster even earlier in its setting time, when it is still liquid and easy to pour. Setting time and the period of plasticity are both influenced by the amount of water used to mix the given amount of plaster — the water-to-plaster ratio.

WATER-TO-PLASTER RATIO

A basic property of any plaster is its "normal consistency," or the amount of water required to mix a given amount of plaster to a standard fluidity. Both the plaster and the water are measured by weight, and the required amounts are expressed as a numerical ratio. A mixture of 1 lb. of water to 1½ lbs. of plaster, for example, can be expressed as two parts of water to three parts of plaster, or a 2:3 ratio. Usually, the equation is expressed in terms of 100 parts of plaster. The 2:3 ratio would then become 67:100. When 100 parts of plaster are added to 67 parts of water, the mixture has a particular consistency and this is expressed by the number 67 alone. The number 80 would express the consistency of the mix when 100 parts of plaster are added to 80 parts of water.

As the number refers to the amount of water used per 100 parts of plaster, the higher the consistency number, the more fluid the mix will be. When less water is used and the mix is therefore less fluid, the setting time and the period of plasticity for the mix are comparatively short. When more water is used and the density of the mix is reduced, the setting time is lengthened.

The consistency affects not only the setting time but the hardness and the compressive strength of the set plaster as well, which in turn correlates closely with resistance to breakage and useful life. The higher the consistency number, that is, the more water required, the softer and weaker the final plaster that results. This is because plaster becomes solid by the formation of tightly interlaced gypsum crystals; as more water is added, these crystals are pushed farther apart, thus making for a weaker structure.

A consistency number in the 65 to 85 range indicates that the set plaster will be of medium hardness. U.S. Gypsum rates the consistency values as follows: 94 to 77, soft to medium; 76 to 59, medium to hard; anything less

than 58, hard to extra-hard. It is extremely important, therefore, to consider the ultimate use of the plaster mix not only in choosing the type of plaster to use but also in adjusting the water-to-plaster ratio for the chosen plaster. Remembering that as you increase the amount of water you lose hardness and strength in the set plaster, you must decide whether workability (such as carving) or strength (such as longer mold life) is more essential for your purpose.

The water-to-plaster ratio is important in another respect as well. When proper proportions are being mixed, the plaster gradually reaches a creamy state, becoming opaque when seen on the hand or stirrer. It is not thin and watery. When it has reached the opaque stage, it is practically ready to be poured. One can be misled, however, if the water-to-plaster ratio strays too far. If too much *plaster* is present, the mix will appear to be creamy and opaque in a much shorter time; but when poured it will sit with water on the surface and take an extra-long time to set. This results in a non-homogeneous piece — the plaster will be porous on top and hard on the bottom. If too much *water* is present, the mix will take an extra-long time to reach the creamy stage and then, all of a sudden, it will set overly fast. The piece will still have good homogeneity, but the set plaster will be softer than it would have been had the desired ratio been used.

In either case, after you have gained experience and have become acquainted with the material, you will achieve a "feel" for the plaster; you will be aware of any imbalance in the mix early enough in the mixing process to remedy it by adding a dash of one or the other ingredient to bring about the balance.

It is advisable, then, to mix several small test batches (approximately 1 pound) of the plaster you have chosen for your particular work, until you have acquired a little of the feel of a proper ratio. Learning to recognize the various stages in setting as the changes occur, the precise consistency to use, and the proper time to pour or shape any particular plaster can best be determined by your own experience with it, since many variables in shop and studio techniques influence the results.

A GENERAL GUIDE

As a general guideline to a water-to-plaster ratio, we have found that the best all-around mix for our plaster purposes is: 1 lb. of water for every 1½ lbs. of plaster (which, incidentally, is the same as a consistency of 67). This is easy to calculate and the mix provides a good, firm plaster model or mold.

A tried-and-true method of mixing plaster — one that

does not depend on weighing the ingredients, and one that generally yields good results — is to add plaster to a given amount of water until the plaster barely breaks the surface of the water. This method is fully described in Chapter 4.

MORE COMMON PROPERTIES

Before indicating some of the differences in plaster, we shall point out some more very basic characteristics common to *all* types of plaster; some of these may sound a bit foolish in their simplicity, but it is often a very basic and simple assumption that goes unexplained which causes trouble.

Plaster is mixed with water — not with oil, not with turpentine, but with good, clean, room-temperature water.

Plaster is added to the water — never add the water to the dry plaster.

Plaster adheres to plaster. There are times when one wishes this were not true but, generally speaking, we make this property work for us when necessary, as in patching and repairing. When we do not wish plaster to adhere, we must protect one plaster surface from another by using a separator or "parting agent." This is a coating that is applied to a plaster surface which has already set before wet plaster is poured over that surface. Lacquer, shellac, thin oil, mold-grease, and soap solutions are all variations of parting agents.

Plaster is primarily an indoor material. Attempts have been made to weatherproof plaster for outdoor use by such means as immersing it in boiling linseed oil, but these methods have not proved very successful.

The setting time of plaster is affected by several factors. Plaster sets up (becomes solid) not only according to the water-to-plaster ratio but also according to the temperature of the water and the speed and duration of agitation. The warmer the water, the faster the set; also, the longer and more violent the agitation, the faster the set. Extraneous material can also be added to the water to affect the setting speed: alum or salt increases it; alcohol or glue-size retards it.

Plaster should always be carefully stored. Since this material is so hygroscopic (water-seeking), it should always be stored in as dry an atmosphere as possible, and its age should be noted. Older plaster runs the risk of having already absorbed moisture, making for lumping

and unevenness. (In the gypsum cements Hydrostone, Hydrocal and Ultracal — see list below — the age of the stored material determines the speed of setting, which takes longer, by as much as 20 minutes, the older the material gets.)

Plaster can be used for both models and molds. As a model material, it is ideal because of its workability; as a mold material, its faithfulness to detail cannot be surpassed.

TYPES OF PLASTER

There are primarily three types of plaster available to the artist/craftsman:

No. 1 Industrial Molding Plaster, often referred to as "soft plaster" or "plaster of Paris," is the softest, the most porous and has no surface-hardening additives, thus is easily carved and best fitted for models and waste molds. It is best used at a consistency of from 67 to 80, which sets in 20 to 35 minutes.

No. 1 Casting Plaster is widely used, mixes easily, and is slightly harder and denser than Molding Plaster. It has a small amount of a hardening additive and develops a hard surface upon drying; thus it is good for castings which are to be painted, such as figurines. It has good chip resistance and is best used at a consistency of from 67 to 80, which sets in about 25 to 30 minutes.

Art Plaster is similar to Casting Plaster but is not as hard or as chip-resistant.

In addition to these three plasters, there are available a number of higher strength gypsum cements produced by special formulation. These produce casts which are generally four to five times stronger than those made of ordinary plaster, but their use is limited to situations in which the plaster does not require carving and forming. The following is a partial list of these harder cements:

*Hydrocal A-11** has a low coefficient of expansion, is smooth and hard-surfaced and is used in pattern-making for industry. This has a short period of plasticity and stiffens rapidly. It sets in about 20 minutes, at a consistency of from 45 to 55.

*Hydrocal B-11** also has a low setting-expansion, but has a high degree of plasticity and a gradual setting action. At a consistency of 50, it sets in about 25 to 30 minutes; it is also available in a very slow-set version which takes about an hour, for use on very large patterns.

*Hydrostone** is one of the very hardest cements and is used at a consistency of from 32 to 40. The heavy, syrupy consistency cannot be worked in a plastic state and the set plaster is not suitable for carving. The mix sets in about 15 to 25 minutes.

*Ultracal 30** is harder and stronger than Hydrocal, and it has the lowest expansion of all. At a consistency of 37, this cement has a gradual set (about 30 minutes) and a long period of plasticity. It is used in pattern-making, and is also available in an even slower set, called Utracal 60* (consistency of 38).

Of all these plasters and cements, No. 1 Molding Plaster is the one most used in model-making and, unless otherwise noted, this will be the material referred to throughout this book. Molding plaster is usually readily available in 100-lb. bags at local building supply houses or ceramics supply stores. Smaller quantities of plaster of Paris are available at local hardware and art supply stores.

*Trademarks owned by United States Gypsum Company

2. Facilities and Tools

THE WORK AREA

There is no reason to shun plaster as an unmanageable material if a few basic rules are considered at the outset. To dispel the fear of handling plaster, one must simply plan ahead. Plaster is a marvelous material, but it can cause chaos if tracked into the living room. Obviously, a work area is a must — the more remote from home furnishings, the better. Controls in the work area, such as old rugs or floor mats, will prevent any tracking of plaster into living areas. The work area must, of course, have some source of water for mixing the plaster.

When planning your facilities, keep in mind the following point: Once you mix a batch of plaster, you are *immediately* faced with three problems — what to do with the mix, what to do with the excess (there should always be some excess, as it is far better to have mixed too much than too little), and what to do with the mixing container after pouring. The solutions are simple.

First, pour the mix into the mold, coddle, or boarded form for which it was intended. Then pour the excess into a disposable trash container (empty plaster bags are often used for this). And finally, clean the mixing container in water right away, or the residual plaster will harden inside.

Three basic requirements, then, are: advanced prepara-tion for the pour, a trash container near at hand, and a water-rinsing facility. Preparing for the pour will be dis-cussed in detail in the next chapter. The trash container should be disposable because, knowing that plaster hardens into a solid mass, you cannot expect to remove the poured excess and reuse the container. For the same reason, you can hardly use the kitchen sink as a rinsing facility unless a special trap is installed. The next best solution for rinsing plaster-laden containers and tools is to provide the work area with a large barrel or drum filled with water. The mixing containers and tools can be dipped into the water and rinsed of plaster with a scrub brush. The plaster will sink to the bottom of the drum, where it forms a residue.

Since the amount of plaster is comparatively small in each rinse, it is usually a long time before the residue builds up and the drum needs emptying. To empty the drum, the settled water is dipped out into buckets or a nearby sink, and the residue of old plaster is then left to dry a little. Before it dries completely, it can be scooped out and placed into disposable trash containers. The drum can be refilled with water and the process started again.

Plastic or rubber basins or buckets are ideal as mixing containers because they flex without breaking; thus any plaster that has escaped the scrub brush can be flaked off when it dries.

THE WORK SURFACE

A workshop for plaster should have sufficient space for a suitable work table, which should be provided with a proper surface.

Traditionally, the best working surface is marble; also very good is plastic laminate sheet, such as Formica, which can be mounted to the tabletop. Either material will provide a fine, smooth surface on which to cast, and will take pencil marking well, which is necessary in laying out guide lines. Some craftsmen use a sheet of heavy plate glass as a work surface.

The bench or table used in casting should *not* be solid as a rock but — to the contrary — should be shakable. This is so that the liquid plaster, once poured, may be agitated by shaking the table, thus helping to level the surface of the plaster and bring air bubbles to the surface, where they may be scooped off by screeding (a process repeated many times).

BASIC TOOLS AND SUPPLIES

The following is a list of what might be considered necessary supplies for mold-making and model-making techniques described in this book.

For Forming Retaining Walls

Clay. Water-base modeling clay comes in 25-lb. bags at ceramic or sculpturing suppliers; certain art supply stores carry smaller bags of it.

Water-base clay is used to seal the seams formed by the linoleum or wooden retaining walls. It is also used to block off areas of a model so mold sections may be cast in sequence.

Since this clay does air-harden fairly rapidly, it is wise to keep it covered with damp rags and store it in a lidded container, removing only the amounts needed at one time. Though the hardening and shrinking factors do cause the working pace to be rather brisk, water-base clay is still preferred over plasteline for the following reasons: It provides a surface smoothness that is never possible with plasteline; its consistency can easily be changed to any desired degree of workability (by adding water if it is too stiff, or by a few minutes of air exposure on plaster slabs if it is too soft); clay can be easily removed and completely washed off the plaster, while plasteline may leave a small residue of oil; clay is less expensive than a matching amount of good plasteline.

Linoleum. Strips and pieces of smooth, untextured linoleum are available at flooring stores. Use widths ranging from 6 to 18 inches and lengths ranging from 8 to 16 inches.

Plywood boards. Obtain exterior or marine grade boards from lumber stores. Use ½- and ¾-inch thick boards in widths of from 6 to 12 inches and in assorted lengths ranging from 12 to 24 inches. Since boards are usually used in pairs, obtain two of each size.

Clothesline rope and **clothespins** are needed for tying and clamping coils of linoleum together.

Steel reinforcing rods, ⅜ of an inch in diameter, are used for clamping boards together. Obtain 16 feet, cut into four 4-foot lengths, from construction supply dealers.

For Mixing Plaster

Scales. A kitchen, bathroom or industrial scale can be used for weighing plaster and water.

Rubber or plastic basin, pans and buckets. Use assorted sizes of one pint to several gallons.

Mixing spoons. Plastic ladles or old serving spoons are useful.

Flour scoop. This is good for handling the dry plaster powder.

For Soaping Models or Molds

Sponges. Use natural sponges 3 to 5 or 6 inches in diameter and use a good grade with as much of the net-like growth as possible still untrimmed.

Bristle brushes. Use small sizes (1, 2 and 3 inches) of the type used for oil painting.

Liquid soap. Obtainable from ceramic suppliers, there are several commercial products, the best of which is English Crown Soap, or material called "Plaster-Lube."

For Forming Wet Plaster

Plaster-turning tools. These are designed and made especially for plaster turning and are available at leading art supply stores or ceramic suppliers.

Steel Spatulas and Modeling Tools. These are similar to wood modeling tools but are made of steel for use with ceramic clay and with plaster. Available from ceramic or sculpturing suppliers.

Sheet metal and tin snips. Sheets of galvanized metal, or .005 brass or zinc, can be cut with tin snips to form templates which are passed over the wet plaster. Metal is available at builders' suppliers; tin snips at hardware stores.

For Cutting Hardened Plaster

Surform files, carpenter's saw, rifflers, rasps, files and wood-carving chisels and gouges are all used to cut or scrape hardened plaster. Most are available at sculpturing suppliers; some at hardware stores or tool and die-makers' suppliers.

Tools ranging from old hacksaw blades to die-sinkers' rifflers accumulate over the years and become personal favorites. All tools must be kept clean. Plaster is very hard on cutting edges, as it is not only highly abrasive but contains water as well; therefore the danger of rust is ever-present. After each tool has been used for cutting either wet or hard plaster, clean it with a knife blade or a wire brush. Frequently apply a light coat of oil.

Miscellaneous Tools

Small bubble level. This is necessary for making sure surfaces are level.

Steel Square. This is essential for determining perpendicular surfaces and for finding parting lines.

Inside and outside calipers, vernier calipers. These tools are important for measuring dimensions accurately.

Indelible pencil. For marking purposes. The indelible marks may be removed from a marble work surface by sanding the surface lightly with fine-grained sandpaper. They will also eventually wear off without sanding.

Fig. 1. Plaster-turning tools.

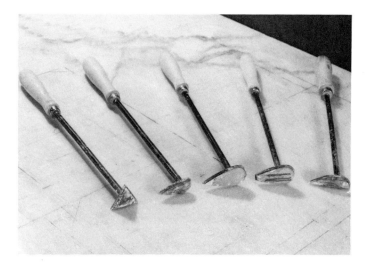

Rubber mallet. For tapping molds to release models.

Steel hammer. For sharp raps to release cast models.

Duco cement. For gluing pieces of plaster together, usually model parts.

Straightedge scrapers. Steel scraps, lawn-trimmer blades, etc., are used for screeding plaster.

Surface gauge. For establishing constant height above the work surface; available at machine tool suppliers.

Rubber tile. For close scraping around model without damaging surfaces.

Inner tubing. Cut into bands or loops of various widths, usually about 1½ inches wide, for tying together assembled molds or blocks and cases when casting.

Sandpaper. Very fine and medium grades for finishing plaster surfaces.

3. Preparing for the Pour

Since poured plaster is a liquid, it naturally must be contained by something until it sets up and becomes a solid. When plaster is poured into a mold, the mold itself is the container. Otherwise, walls must be erected to form boundaries around the model being cast into a mold or around empty space being cast into a form. For this, we use what is called a coddle (sometimes called a cottle), or we use a box form (Fig. 2). We can also use water-base clay to quickly form retaining walls for casting thin, rectangular slabs of plaster and other low-profile shapes.

CODDLES

By a coddle we mean a piece of linoleum or flexible sheet plastic that is wound around itself to form a cylinder open at both ends. One end rests on the work surface; the other is "up" to take the pour of plaster (Fig. 3). The cylinder can be used alone to cast a plaster form or it can be used to surround a model to form the outer boundaries of a mold.

Any flexible, smooth, substantial material will do for a coddle. Untextured linoleum is most commonly used because scrap pieces are readily available from flooring dealers. These strips, cut from rolls of linoleum, have a built-in tendency to stay rolled and are therefore easiest to handle. The linoleum should be fairly warm before it is unrolled; cold linoleum will crack. Various heights and

lengths should be acquired so that the coddle can be appropriate in size to the model you intend to surround or the form you intend to cast.

FIRMING UP THE CODDLE

The coddle is coiled around itself and held in a closed cylinder with clothespins clamping the ends (Fig. 4). Soft clay is put around the bottom, acting as a seal and helping to keep the linoleum in proper shape and position. Finally, a length of cord is wound around the wall of the cylinder to a height of the anticipated pour; the end of the rope is slippery-hitched for quick untying (Fig. 5).

BOX FORMS

If the size or shape of the model or form does not lend itself to the use of a coddle, we can form a box around it, using four plywood boards to do so (Fig. 6).

As mentioned in the list of basic supplies (page 14), you should have assorted sizes on hand. Your collection will grow as needs arise. All boards should be sealed with sanding sealer and then varnished. (Excellent boards with super-smooth surfaces can be made from the sink-top blanks left over when kitchen countertops are cut. These

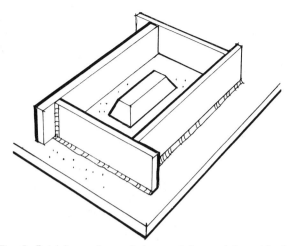

Fig. 2. Retaining walls erected around the model provide the casting area for poured plaster.

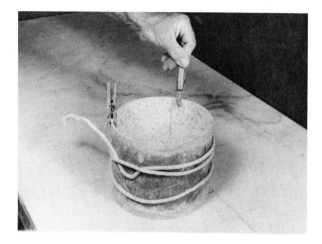

Fig. 3. The coddle is a cylinder of linoleum that provides the casting area.

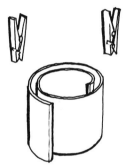

Fig. 4. Coil the linoleum with the smooth surface inside and fasten with clothespins.

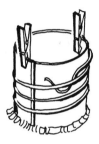

Fig. 5. The clayed-up coddle ready to receive the cast.

Fig. 6. The box form. Note offset manner of placing boards, and note clayed seams.

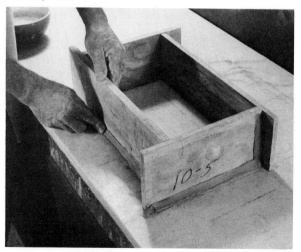

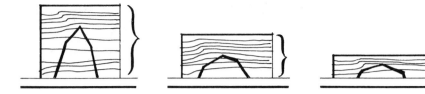

Fig. 7. Suit the board size to the object size.

are available from lumberyards and building contractors. The blanks are already covered with laminate plastic and can be sawed down to your requirements.)

In forming the box, we use boards appropriate in thickness and in size to the job at hand; if the piece is large in all dimensions, we use boards ¾ of an inch thick to give the most support to a sizable quantity of plaster; if, on the other hand, the piece is small, then ½-inch thick boards may be used, with a correspondingly lower wall height (Fig. 7). The boards should be sturdy enough not to bend when clamps are applied.

The boards are butted together in an offset manner as illustrated in Fig. 6. Soft clay is placed firmly along the outside seams around the bottom and up the vertical seams where the boards come together.

When the clay has been affixed, a length of rope is wound firmly around the box and slippery-hitched as with the coddle. A wedge of wood is often placed at several points inside the wound rope to increase the tension (Fig. 8).

On all large boxes, clamps are used instead of ropes to be sure there will be no leakage of plaster or collapsing of walls under the pressure of the liquid plaster (Figs. 9 and 10). On very large casts, the boards should even be nailed to one another to insure that they maintain their position despite the pressure of a large amount of plaster.

Fig. 8. Box form is tied using wedges and rope to keep it firm.

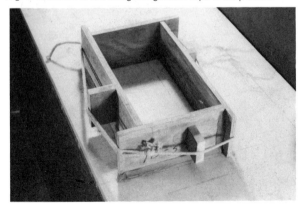

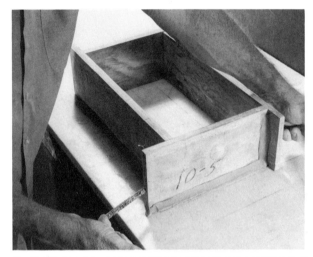

Fig. 9. Clamps are used on large box forms to prevent leakage of plaster under added pressure.

Fig. 10. Proper positioning of clamps on box form.

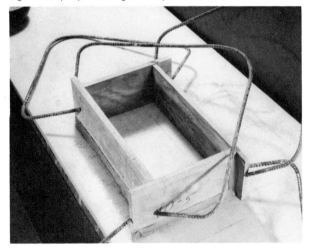

18

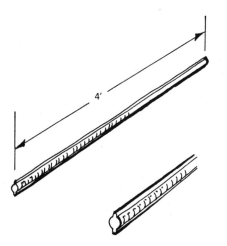

Fig. 11. A 4-foot length of construction rod makes a good clamp.

Fig. 12. Bend the rod 90° at a point 8 inches from each end.

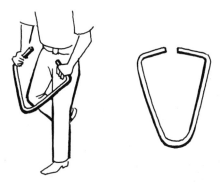

Fig. 13. Bend the center into a V-shape.

Fig. 14. Clamping positions on box forms to apply straight-line pressure on boards.

MAKING CLAMPS

Fig. 15. Clamps applied in addition to loop of inner tubing to hold mold closed.

Holding-clamps can be made from steel reinforcing rods available from construction supply dealers. Obtain at least 16 feet of ⅜-inch diameter rod, cut to 4-foot lengths (Fig. 11). (Some suppliers stock 4-foot lengths.) From each end of the 4-foot rod, mark off 8 inches and make a sharp bend at those points by placing the rod in a vise and pulling the long end in a perpendicular direction (Fig. 12). Then, using your knee as a guide, bend the rod in the middle to form a soft V-shape (Fig. 13). Make four such clamps.

These clamps can be opened up or closed down to maintain good tension on board setups of various sizes. They are placed to apply straight-line pressure on the butted boards (Fig. 14). They are also used to hold molds tightly closed (Fig. 15).

SOAPING, OR APPLYING
THE SEPARATOR

Since plaster tends to adhere to many materials, especially to itself, separators or parting compounds are an absolute must. Before any plaster is cast into a mold or over a model, a parting compound must be applied to every surface with which it will be in contact. This means the marble work surface and every retaining wall as well as the model itself.

One of the most commonly used compounds is liquid soap. This is available from ceramic supply houses. The best is a jelly-like product called English Crown Soap. This is dissolved to proper consistency in warm water and, after cooling, is kept available in this liquid condition. If English Crown soap is not available, other commercial substitutes will undoubtedly be recommended by the supplier.

The linoleum and the plywood boards should be soaped before the coddle or the box is formed. The linoleum and the boards (which are sealed with varnish) require only one coating of soap before they are used. When casting plaster against a plaster surface, however, as when making a piece mold (Chapter 6), it is necessary to coat the plaster surface more than once. The following procedure is a guide to soaping a plaster surface and it should be referred to whenever techniques require you to cast plaster against a plaster surface.

To properly "soap" a piece of plaster, one must simply

insure that the pores of the plaster near the surface have absorbed enough mold release (soap) to prevent the plaster from sticking; the visual signal that this condition has been attained is the appearance of a gloss or semi-gloss on the surface.

Before soaping any piece, be sure that the plaster is damp. Often a plaster model or mold has been stored and is dry; if this is the case, it should be immersed in water for a brief second or two — not longer or too much water will be absorbed. If it is not convenient to immerse the piece, it should be dampened with a wet sponge.

It is advisable to have three natural sponges for soaping. The first is a "water sponge," about 5 or 6 inches in diameter, used to dampen and clean off the models or molds as just described. The second sponge is the "soap sponge," about 3 inches in diameter, and is used exclusively to apply the soap. The third is the "finishing sponge," about the same size as the soap sponge, and is used to absorb the excess suds.

Always grasp the sponges in the same place, on the opposite side of the work-face, and always keep the sponges in a small bowl, work-face up. Synthetic sponges are to be avoided.

In soaping, do not use a thin consistency; keep the soap on the thick side. In using the soap, never work from your main supply, but pour an appropriate amount in a small bowl and dip the sponge into that supply.

Using the soap sponge, apply the liquid soap liberally over the plaster surface of the model or mold (Fig. 16). The

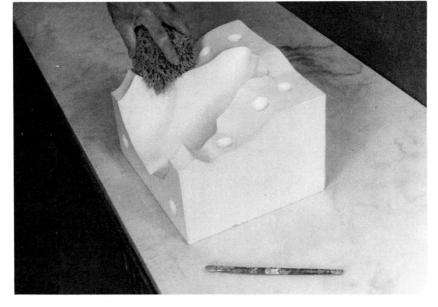

Fig. 16. Use natural sponges to soap plaster molds and models.

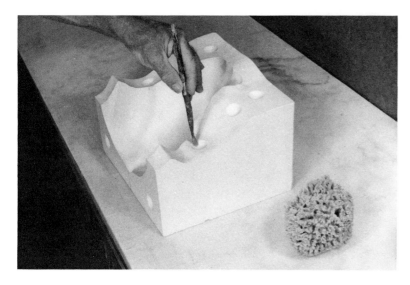

Fig. 17. Use a bristle brush to lift excess soap from small crevices.

plaster takes only 15 or 20 seconds, to absorb the soap, which can be seen to soak in. As soon as the plaster has absorbed this first coating, apply another coating of liquid soap. Continue to repeat these procedures, alternately waiting for absorption and then resoaping the plaster, until a gloss appears on the plaster surface. It may take as many as eight or ten repetitions, all within a few minutes, to acquire this gloss. When the gloss appears over the entire mold or model, enough soap has been applied. (This gloss does not always remain; the plaster usually becomes semi-glossy or even dull after sitting a short while.)

When this glossy condition has been attained, use the finishing sponge to pick up any surplus soap that has accumulated, especially in dips and hollows of a piece. No suds should remain, nor should any part be touched by the hands, once the plaster has been soaped. If it is necessary to handle a piece after having soaped it, the piece should be resoaped in that area.

Pay careful attention to small crevices and intersections, as they tend to gather suds; use a small bristle brush to remove froth from these trouble spots (Fig. 17). Remember that, wherever a bubble of soap remains, the detail of the piece will be missing in the plaster cast over it.

Often in the rush of things, doubt may arise as to whether you have or have not soaped a certain piece; in these cases, always soap again — play it safe.

This completes the soaping operation and the plaster surface is then ready to receive fresh plaster. Remember, *avoid touching* soaped areas.

When casting plaster over models made of any material

that absorbs moisture, be sure to soap the model. If a model is encountered that is exceedingly porous, such as a model made of wood, it should be sealed with thinned brushing lacquer or with shellac thinned with alcohol before the separator is applied. However, care must be taken not to lose the detail of the model by coating it too thickly.

OTHER SEPARATORS

In addition to liquid soap, there are other separator materials and parting compounds used in some workshops. We will mention them in passing but wish to emphasize that liquid soap is generally accepted as being the standard separator for plaster in the craft field. Some of these other compounds are:

Stearic acid and kerosene. This is made by dissolving ¼ lb. of stearic acid, shaved to flakes, in 1 pint of kerosene. The stearic acid is gradually melted by warming, then removed from the heat, and kerosene is gradually stirred in until the desired consistency is obtained. This must be done with precaution because of the *fire hazard.*

Petroleum Jelly. Carefully heat and blend two parts kerosene to one part of jelly. Again, be careful of the *fire hazard.*

Automotive Oil, 30 wt. Paint the oil on with a small brush. This procedure is especially good on porous wood models that have been sealed. The oil may also be used to help soaped boards slide away from wet plaster (Chapter 9).

4. Mixing and Pouring Plaster

When the dry, powered plaster is put into water, each particle becomes wet, and action is started that is irreversible, ending with the crystallization or hardening of the powder into a solid. The correct method of accomplishing this wetting-mixing action is as follows:

1. Water is put into a mixing container.
2. Plaster is gradually sifted into the water at a rapid rate.
3. The plaster-water combination is allowed to sit undisturbed for a short while (usually one to three minutes).
4. The combination is then mixed, being agitated either by hand, or by an implement such as a spoon or spatula, or by a mechanical beater or electric mixer.
5. Agitation is stopped and the mix is poured.
6. The excess plaster is poured into a trash container.
7. The mixing container is quickly rinsed and cleaned.
8. The mix "sets up" into a hard solid.

VOLUME AND WEIGHT

In mixing plaster, we are constantly dealing with both volume and weight. When we refer to consistency numbers, the plaster and water are always measured by *weight*. Yet, when we have a box form or a mold of a given size to fill, we are first confronted with the question of how much liquid plaster it will take to fill the form — a question of *volume*.

The first step, then, is to determine the volume of liquid plaster it will take to fill the form. This must be an educated guess based on previous experience and visual estimates. In addition, this estimate should include a bit more liquid plaster than you actually need. It is far better to mix too much plaster than too little because a mold cast in two mixes will never be as uniform as one poured all at once. From this estimate, we can then deduce the volume of water required by subtracting 35 to 40% from the total volume. This percentage is what the dry plaster contributes to the total volume when added to the water.

Thus, if we estimate that a mold will need about a pint of liquid plaster, we can subtract 35% for the plaster and safely figure that the amount of water needed will be 65% or about $2/3$ of a pint. If we estimate that a mold will need $1\frac{1}{2}$ pints of liquid plaster, we can figure the amount of water needed will be 65% of $1\frac{1}{2}$ or about a pint ($.65 \times 1.5 = .975$). Since estimating the required volume becomes easier with experience, it is important that you keep a record of all your casts, making notes on the volume of plaster each item took to cast. (Weigh any excess plaster before discarding it.)

Once this *volume* of water is decided upon, you then have a choice as to how to arrive at a good mix. For most craft purposes, a good, average water-to-plaster ratio can be achieved visually, without weighing. This is accomplished by placing the estimated volume of water into a container and then gradually sifting plaster in until it just

breaks the surface of the water. This will be described in more detail later (page 24).

On the other hand, if there is a need to be more accurate, you can *weigh* the volume of water and then calculate by *weight* the amount of the plaster to be added in the following manner. First, place an empty mixing container on a scale (bathroom, kitchen, or commercial) and note the container's weight when *empty* (Fig. 18). Then put the desired volume of water in the container and note the combined weight of both (Fig. 19). By subtracting the first reading (the weight of the container) from the second reading (the combined weight), you find the weight of the water. With this known value, you can now calculate the weight of the plaster needed.

If you are following the simple water-to-plaster ratio of 1 lb. of water to 1½ lbs. of plaster, simply multiply the weight of the water by 1½; this will give you the weight of the plaster to be added. For instance, if the water weighs 2 lbs., the amount of plaster to be added would be 2 × 1½ or 3 lbs. of plaster.

If you are working with consistency numbers and wish to convert the consistency ratio to pounds of plaster per pound of water, simply divide the consistency number (required parts of water) into 100 (required parts of plaster). This gives you the amount of plaster required for *each part* of water and therefore the weight required for each pound of water. For instance, the consistency of 67 divided into 100 means 1.5 parts of plaster are needed for each part of water, or 1½ lbs. of plaster for every 1 lb. of water. Similarly, if the water-to-plaster ratio desired is a consistency of 80, then 80 divided into 100 gives a result of 1.25 parts of plaster for each part of water, or 1¼ lbs. of plaster needed for every 1 lb. of water. Again, the amount of plaster needed per pound of water is multiplied by the weight of the water you have in the container.

With the plaster weight calculated, you have three known values, all of which are in pounds and can be read on the scale. If the empty container weighed 1 lb., and the desired volume of water weighed 2 lbs., their combined reading on the scale would be 3 lbs. If you know you need to add 3 lbs. of plaster, simply sift plaster into the container of water on the scale until the combined reading is 3 plus 3 or 6 lbs. (Figs. 18, 19, and 20).

THE FIRST CAST

We can now proceed to make a practice cast, putting into effect all the techniques we have discussed so far and going on to the actual pouring techniques.

First, obtain a pint-sized plastic container with tapered sides, such as is used to hold cottage cheese; this will serve as a mold. With a small, moist sponge, apply a light coat of liquid soap to the inside surface of the mold. Also soap the surrounding work surface of the table or marble, applying a thin film of soap.

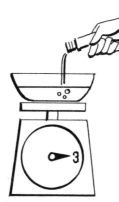
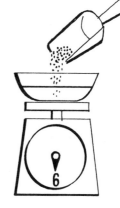

Fig. 18. Weigh the empty container.

Fig. 19. Add water and note the combined weight.

Fig. 20. Add plaster until the scale shows the previous combined weight plus the required weight of plaster.

23

Fig. 21. Always add the plaster to the water; sift plaster in gradually.

Fig. 22. Add plaster until it just breaks the water's surface.

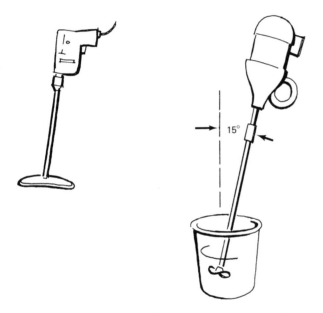

Fig. 23. Power mixers are used for large batches of plaster. Small batches are mixed by hand.

Mixing without Weighing

Place about a pint of room-temperature water in a mixing bowl. Using your hands, dip into the plaster supply and sift the powder by the handful into the water, trying to spread

the drop as evenly as possible. Do not dip your hands into the water, but let the plaster fall freely through your fingers (Fig. 21). If you encounter any hardened pieces, be sure to discard them.

Continue this operation until the level of the plaster has just broken the water's surface, leaving a very thin film of water (Fig. 22). If little mounds of plaster are left rising above the surface, do not push them under; wait until they become soaked through by capillary action.

Slaking and Stirring

Allow the mix to stand *undisturbed* for at least one minute. (The mix may stand for longer periods of time, up to six to ten minutes when you are mixing large quantities of plaster.) You may tap the sides of the mixing container while waiting, to bring air bubbles to the surface. This waiting period is referred to as *slaking*.

After the slaking period, begin to stir the mix with your hand or a spoon, or some other similar instrument. Keep the stirring action below the surface so as not to trap any additional air bubbles. Air bubbles are the nemesis of the plaster worker; wherever they form and are allowed to remain, they prevent the plaster from filling in that particular spot. The stirring motion should be from bottom to top in order to bring the bubbles to the surface, where they may be skimmed off with a spoon before pouring.

The longer and more rapidly the mixture is stirred, the sooner it will set. Therefore, if a mechanical mixer, electric mixer, or commercial power mixer is used, the mixing time will be reduced considerably, one minute usually being enough time. If you mix by hand, three minutes is usually enough time.

(Small quantities of plaster and water, 5 to 25 lbs., are usually mixed by hand or spatula; for batches 25 to 50 lbs., a ¼-inch electric drill can be used with a 5-inch rubber disk. For larger mixing operations, the most efficient tool is a motor with a direct-drive 1760 RPM propeller mixer. For batches up to 50 lbs. of slurry weight — the weight of the wet plaster in water — a ⅓ HP motor will suffice; for between 50 and 100 lbs. of slurry, a ½ HP motor should be used. Best results are obtained when the propeller is clear of the bottom by 1 or 2 inches, and is set at an angle of 15° with the vertical while a little off-center in the container. See Fig. 23.)

When mixing by hand, you may encounter small lumps or hardened bits of plaster in the mixture. Discard these and continue mixing. Gradually, the mix will lose its watery consistency and begin to take on a creamy, thicker texture. This usually happens as the time comes up to the three-minute mark; the mix is then ready to pour.

Pouring

Lift the mix over the mold, in this case the cottage-cheese container, and carefully pour it in a small, continuous stream in one spot, letting the plaster flow freely up and around the inside of the container until it crests just above the lip of the mold (Fig. 24). Tap the sides and gently shake the mold-container to release air bubbles that will rise to the top. Pour the excess plaster left in the mixing bowl into your trash container. Quickly dip the mixing bowl into the water barrel, and, with the hand or a scrub brush, remove any plaster sticking to it. Then turn your attention back to the mold.

Fig. 24. Let plaster crest at top of pour.

Screeding

The surface of the just-poured plaster will appear as shiny as water at first. As the plaster "sets up," this shine disappears and gradually becomes dull. Test the firmness of the set by touching the crest of the poured plaster with a metal straightedge; when the plaster has reached a mushy state, take the straightedge lightly across the surface to remove *some* of the plaster, but not all of it, in one pass. Make three or four passes to remove the crest of plaster a little at a time. This will prevent ripping up the smooth plaster surface (Fig. 25). This passing over a plaster surface with a straightedge is called "screeding."

When the top of the plaster has been screeded flush with the lip of the mold, let the cast sit for several minutes; then sprinkle the top with a few drops of water and screed it again. You will find that the plaster has expanded and that you have screeded a small amount off the surface. Clean the straightedge each time you pass it over the plaster.

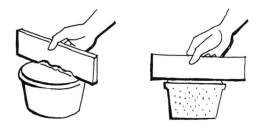

Fig. 25. Make several passes in screeding.

After Screeding

As the plaster continues its setting-up action, it becomes hard to the touch. You will also be able to detect a gradual build-up of heat as the crystallization takes place. When the plaster is at its hottest, it is also at its point of maximum expansion. Upon cooling, the plaster shrinks slightly, but never returns to its previous unexpanded size. In all work, expansion — either within a mold or over a model — can be a crucial factor, and the plaster's warmth or coolness can be used to indicate when the cast or mold is ready to be removed. (See page 26.)

In this case, the cast may be removed when the plaster has cooled, by inverting the mold and tapping it. After the cast is removed, examine it for holes caused by air bubbles. These may be filled as described in Chapter 12, under patching. Also, take note of the general hardness of the cast for future reference. If the cast seems too soft, adjust the amount of plaster on subsequent casts by adding a little more plaster. If the cast piece seems too hard, remember to leave a deeper film of water on the surface when sifting the plaster in, so the mounds of plaster do not come up as high.

This first cast has produced a plaster model from the cheese-container mold. If we desired to make a mold of this plaster model, we would soap it as described in Chapter 3 and place soaped retainer walls around it, using either a linoleum coddle or a plywood box form. The plaster would be mixed in the same way as before and would be poured over the model within those walls.

The basic processes of mixing the plaster and pouring it into the soaped mold or a containing form are invariable. The real challenge in casting comes with the realization that few forms lend themselves to being cast in one neat package, and additional steps must be added to the basic ones. If the cottage-cheese container were cubical in form, rather than a truncated cone, we would not be able to remove the plaster that was cast in it — unless we were to cut the container-mold into two pieces. The reason for this and the remedy are examined in the next chapter.

5. The Necessity for Piece Molds

DRAFT

When plaster is cast over the model to produce a mold, the cast plaster expands outward, away from the surfaces of the model (Fig. 26). However, when plaster is cast *into* that mold to reproduce the model, the expansion of the plaster is directed toward the walls of the mold* (Fig. 27). If we had an open mold of a cube and were to cast plaster into it, the cube so cast would be virtually impossible to extract from the mold, because the plaster expanding within the space will have created a lock of friction against the walls. Each wall of the mold except the top one must be tapered so the mold can be withdrawn from the cast cube in the direction shown by the arrow (Fig. 28).** This slight taper which must be present in the mold is called *draft*.

Hopefully, an object that is designed specifically for casting will have draft incorporated into its original design wherever possible. Often, however, the original model is made without consideration for draft, and it is then necessary to make the mold so that it will draw freely away from the model's unangled surface. In the case of a cube,

Fig. 26. When mold is produced, plaster expands away from model.

Fig. 27. When mold is filled, plaster expands within the mold, locking tight.

Invert mold after plaster hardens

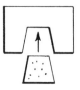

Fig. 28. Tapered walls provide draft and allow withdrawal.

*Remember that plaster grows warm to the touch as it expands and that it is at its point of greatest expansion when it is hottest. Therefore, if you are making a cast *over* a model, as in Fig. 26, it is easiest to remove the model from the mold while the plaster is still warm, at its maximum expansion, since it is expanding away from the model. On the other hand, if a cast is being made *into* a cavity, such as in Fig. 27, it is best to let the plaster cool completely, sometimes for several hours, before trying to remove it, because this is when the plaster has diminished somewhat in size.

**If the two opposing walls of the cube were perfectly parallel and flat, only the other two opposing walls would have to be tapered.

for instance, which cannot be altered to allow for draft, it is necessary to divide the mold into two sections (Fig. 29), each one being withdrawn from the cube surface in the direction shown by the arrows.

UNDERCUTS

Using a tapered cube like the one in Fig. 28 as an example, suppose that the model has been designed to allow for draft but that one of the walls has a V-shaped design incised in it (Fig. 30). When the plaster of the mold flows over the cube, it also flows into the V-shaped portion (Fig. 31). When hardened, this projecting piece of plaster, like the barb on a hook, prevents the mold from being withdrawn. Any indented element in the model which interferes with the function of draft and prevents withdrawal of the mold from the model is an *undercut*. Undercuts can be anything from a small scratch in the model's surface to a major change in direction. In any case, an undercut must be eliminated or planned for.

We can plan around an undercut by dividing the mold into sections so that the angle of mold withdrawal is changed from one of undercut to one of draft (Fig. 32). The sections are planned so that each piece of the mold will withdraw freely.

In addition to clearing undercuts, a mold section must be planned so that it does not embrace a form, literally turn the corners of a form. In order to be withdrawn, it cannot start to wrap around the corner of a form and become a closed U-shape (Fig. 33).

PIECE MOLDS

There are, then, at least two reasons for dividing the mold into sections. First, to provide draft, and second to avoid undercuts. There is a third reason as well. Referring back to the tapered cube (Fig. 28), we can see that the mold formed all surfaces of the model except the bottom one. This surface of the model was formed simply by the plaster poured into the inverted mold and allowed to harden in a level position. This is an example of an open-faced, one-piece mold. If we wished to make a mold of a sphere, we can see that to form all of the curved surfaces we would have to completely enclose the model (Fig. 34). In this case, we must divide the mold into sections simply to extract the model. (When all surfaces of the model are enclosed, a hole is provided in one section of the mold to permit casting material to be poured in. How this is done will be explained in Chapters 6, 7, and 8.) The number,

Fig. 29. If draft is not present, mold must be divided into two sections to withdraw.

 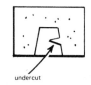

Fig. 30. Model has draft but its notched wall has an undercut.

Fig. 31. Plaster of mold flows into the undercut, which prevents withdrawal.

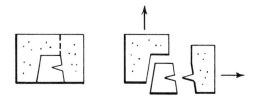

Fig. 32. Dividing the mold into two sections allows withdrawal.

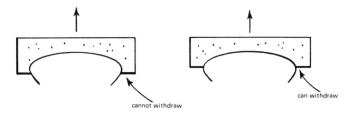

Fig. 33. A mold section cannot embrace the model and be withdrawn.

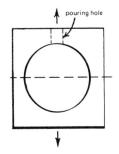

Fig. 34. Sphere within a two-piece mold Mold must be made to enclose the model to form all the surfaces and it must be divided into two withdrawable sections.

shape, and location of the mold sections depend on our allowing for draft and avoiding undercuts. To do this, we must be able to visualize how the mold can be divided so each section will withdraw from the model without engaging any obstacles. The model must really be looked at from all points of view.

THE PARTING LINE OF A TWO-PIECE MOLD

Mold types are named by the number of pieces or sections that go together to form the complete mold: two-piece, three-piece, four-piece molds, etc. There is no theoretical limit to the number of pieces a mold can be, but for practical purposes, the smaller the number of pieces, the better, because of the greatly increased time and effort needed to produce additional sections. It is better to spend time in analyzing a model to keep the number of sections needed to a minimum, hopefully two.

Two-piece molds occupy a special place in the field because they are easier not only to understand but also to make. If we can divide the model into a top and bottom, or a front and back, life stays a lot simpler. Nevertheless, some models demand more than two sections and any attempts to avoid them by over-simplifying or ignoring

undercuts is courting disaster. In the end, the number of sections a mold must have is always determined by the configuration of the model and the analytical ability of the mold-maker. Bearing this in mind, let us proceed to analyze a model.

Taking a sphere as an example (Fig. 34), we know that the mold must be cast in two sections and that neither section may embrace the model. How do we locate the line that divides the sphere into two withdrawable sections?

We see first that the shape of the sphere is the same when viewed from all angles: when defined in two dimensions by its contours, it is always circular; and when defined in three dimensions by its surface, it is always curved. In making molds, we are always dealing with three dimensions, but it is often helpful to consider the shape as it appears in two dimensions.

If we draw any two parallel tangents on a circle and connect them with a straight line (Fig. 35), we not only obtain a diameter that divides the circle into two identical sections, we also see that the curved line reaches its maximum dimensions at each of the two tangent points. The diameter line is the only dividing line that would allow each mold section to be withdrawn. If the circle were divided along any other line, one section would start to embrace the form (Figs. 36 and 37). In addition, the

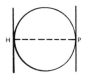

Fig. 35. The curved line of the circle reaches its maximum dimensions at each of two parallel tangent points. A straight line drawn from one point to the other divides the circle and represents a horizontal plane from which each mold section can be withdrawn in an opposite direction.

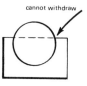

Fig. 37. If the circle were divided along any other line, one mold section would start to embrace the form.

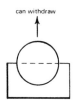

Fig. 36. The diameter is the only parting line that allows withdrawal.

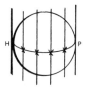

Fig. 38. The dividing line on the sphere is a line drawn through all the tangent points indicating the highest spots on the curved surface. The parting line is a continuous path that encompasses the model at its maximum dimensions.

diameter represents a horizontal plane from which each half of the mold could be withdrawn in opposite directions (Fig. 34).

Just as the two parallel tangents connected by a straight line provide the dividing line for a circle, many parallel tangent lines moved around the curved surface of a sphere provide the dividing line for the three-dimensional model when those tangent points are connected (Fig. 38). Each tangent point indicates the highest spot on the curved surface; the line connecting these points on the model's surface traces a continuous path that encompasses the model at its maximum dimensions. This precise dividing line drawn on the model is the *parting line* or *seam* of the mold, and it too represents a horizontal plane from which two mold sections can be withdrawn in opposite directions.

In actual practice, these high points can easily be marked by placing the model on a horizontal work surface so that its two lateral ends are perpendicular to this surface and then moving the vertical arm of a square around the model while the horizontal arm remains on the work surface. In positioning a sphere, we would always achieve the same results, because each of its maximum dimensions is equidistant from its center. In positioning other models, however, we must first try to visualize how the form might be divided to provide draft.

For instance, suppose that instead of a smooth sphere, we have a model of a head in which the features are fairly realistic and project from the basic spherical shape of the head. If we visualize the surface of each half of the smooth sphere being touched by many arrows parallel to one another, we can see that nothing on the model interferes with withdrawal of either mold section in opposite directions (Fig. 39). If we visually divide the sphere of the featured head, however, into a top and a bottom, and apply the arrows in the same way, we can see that the parallel arrows are prevented from touching certain areas, showing that each projection and indentation would present an obstacle to mold withdrawal — they are undercuts (Fig. 40).

To allow the mold to clear these facial features, the direction of withdrawal has to be changed. By dividing the model into a front and back, thereby changing the parting line location to one which runs from the top of the head down to the neck (Figs. 41 and 42), we can withdraw each section in opposite directions without encountering any undercuts.

The first step, then, in dividing the model is to visually evaluate the solid in terms of withdrawing the mold sections from its large surfaces while avoiding undercuts, and to predict an approximate location of the parting line. The model must be viewed from every angle, from above and below as well as from front, back and sides, to make

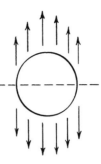

Fig. 39. Parallel arrows show unimpeded withdrawal in opposite directions.

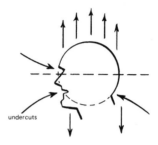

Fig. 40. Facial features form undercuts and prevent withdrawal in either direction shown by parallel arrows.

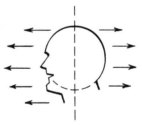

Fig. 41. A shift in the parting line allows withdrawal in both directions shown by parallel arrows.

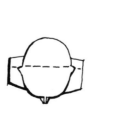 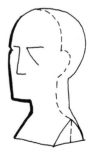

Fig. 42. Parting line runs across the top of the head and down either side of the neck. This can be predicted visually.

certain that the rigid plaster of the mold will not encounter any obstacles at the intended angle of withdrawal.

Having made this evaluation, the next step is to actually draw or scribe the parting line on the model. Place the model on a level work surface with its estimated parting line roughly horizontal to the level surface. Use wads of soft clay to cushion the model and to allow for shifting its position. In positioning the model, look at it from directly above. You should be able to see every surface of the model that is above the estimated parting line. If you cannot see these surfaces, rotate the model around its horizontal axis until you do. It also may be necessary to prop one end of the model up so its undercut surfaces may be viewed from above. Some mold-makers check their work for draft clearance by using a plumb-bob and cord.

The bob is suspended and the point is carefully trailed over the surface of the model. If the point is prevented from touching any of the model surface, an undercut is present. The entire model can be rotated and checked in this manner (Fig. 43).

After the model has been checked for draft, either visually or with a plumb-bob, rub one entire edge of a square with indelible pencil (Fig. 44) and move that edge in an upright position around the model while the second edge of the square is horizontal on the work surface (Fig. 45). As the square is moved, the upright edge leaves a trace of indelible pencil on the high spots it touches. This tracing of the points of maximum dimension along a continuous path on the model's surface is the parting line between the two mold sections which are to be cast.

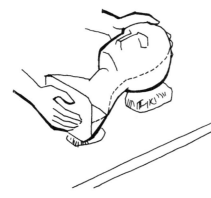

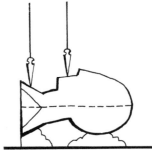

Fig. 43. Place model on horizontal surface and check draft visually or with a plumb-bob. Any area of the model's surface that is facing up and cannot be touched by the suspended point is undercut.

Fig. 44. Indelible pencil is rubbed on one edge of a square to trace the actual parting line.

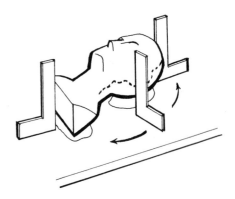

Fig. 45. As it is moved around the model with one arm horizontal and the other arm perpendicular, the square leaves a trace of indelible pencil along the high points on the model's surface.

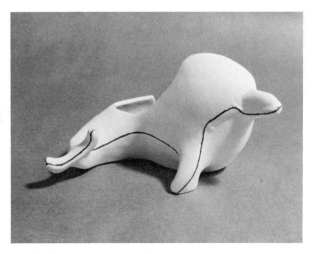

Fig. 46. Example of an undulating parting line for a two-piece mold.

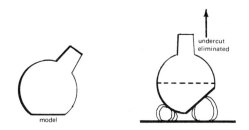

Fig. 48. When the model is positioned in order to mark the parting line, it may be severely shifted to clear undercuts. The parting line obtained may still be horizontal to the work surface.

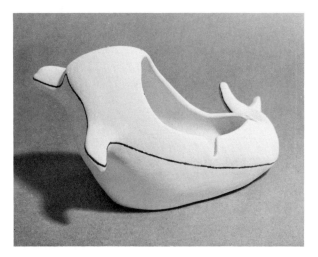

Fig. 47. View of the opposite side; mold withdraws from top and bottom.

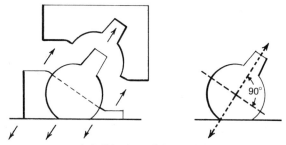

angle of withdrawal perpendicular to parting line

Fig. 49. When the mold is made, the model is positioned so its base, not its parting line, is horizontal to the work surface, and the mold is made to withdraw perpendicularly to the parting line.

As we are no longer dealing with simple, geometric forms, we cannot expect this line to be perfectly straight. It may fluctuate markedly, but it still provides us with a generally horizontal plane from which two mold sections may be withdrawn in two opposite directions. An example of a fluctuating parting line can be seen in Figs. 46 and 47, where the withdrawal is from the top and bottom of the model.

The two mold sections usually withdraw from the model at a perpendicular angle to the general plane of the parting line, but not always. As we noted, the model must be shifted and propped up to achieve clearance from undercuts and still be in a position to have a path of high points plotted around it. In cases where the model is tilted to clear undercuts but the parting line obtained is horizontal to the work surface, the mold can still be made so the sections withdraw perpendicularly to the parting line (Figs. 48 and 49). This will be explained further in Chapter 6. But in

31

cases where shifting the model results in an extremely angled parting line instead of one generally parallel to the level work surface, the mold sections — when made — must withdraw at a different angle to the parting line (Figs. 50 and 51).

Often, due to very small undulations in the model surface, a wavy line is generated when using the square (Fig. 52). Sometimes a slight shifting of the model on the clay supports can eliminate severe peaks and valleys; if not, it is advisable to draw a median line through them to give a gentle curve to the parting line (Fig. 53). If a smooth surface is desired on the final product, the slight variations on the model's surface that caused the extremes can be removed from the mold later with judicious use of scraper and sandpaper.

This method of using the square and a horizontal surface to find the parting line can be used only after you have determined that the mold can be made in two sections.

MORE THAN TWO SECTIONS

A seated figure, as the one in Fig. 54, with the chin and nose angled upward, could be handled as a two-piece mold, with the parting line obtained as previously described, using the square (Fig. 55). If, however, the same figure had its face angled *downward* (Fig. 56), it would be necessary for the direction of mold withdrawal to also be angled downward. This would mean that the mold section could not go beyond a point on the forehead and on the knee, and the parting line or seam would be shifted forward accordingly. With the parting line that far forward on the forehead, it would be necessary to form the back and underside with two additional sections, making this a three-piece mold (Fig. 57). The two-piece technique of using the square to find the parting line could not be used here; in situations such as this, the analysis of the model requires a somewhat different approach.

A helpful part of that analysis would be to use a pencil or

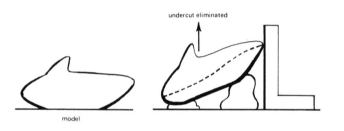

Fig. 50. Shifting the position of the model to avoid undercuts may result in an angled parting line.

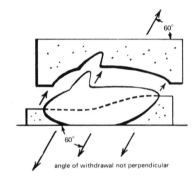

Fig. 51. In these cases, the mold sections, when made, must be removed at a different angle to the parting line.

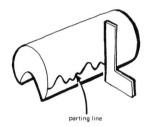

Fig. 52. Surface undulations can cause the parting line traced by the square to be wavy.

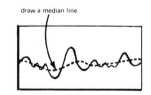

Fig. 53. A median line softens the severe peaks and valleys of the trace.

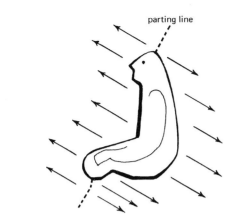

Fig. 54. A two-piece mold is possible with no undercuts.

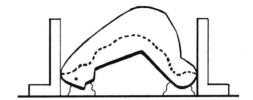

Fig. 55. The square can determine the parting line.

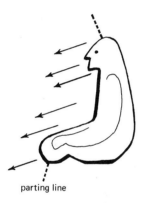

Fig. 56. Parting line must be shifted forward to accommodate withdrawal direction dictated by facial angle of the model.

Fig. 57. With this shift, a three-piece mold is necessary to withdraw from all areas.

piece of straight wire as a physical form of the arrows of withdrawal we have shown on the sketches, touching the wire to various points on the model while holding the wire in a relatively parallel position to give a rough idea of how a section will withdraw. Where we encounter a part of the form that cannot be touched by the wire without changing its parallel position, we know this part of the form will have to be resolved in one of three ways: either by changing the direction of withdrawal, by altering the shape of the interfering form, or by relegating it to an adjacent section of mold. There is a great deal more to the analysis though.

PARTING LINES FOR MULTI-PIECE MOLDS

Once we leave the relative simplicity of one- and two-piece molds, the analysis of the model becomes one that is more subject to the skills and experience of the mold-maker. All that has just been said regarding undercuts and draft remains not only true here but even more so, for the location of the parting line for multi-sectioned molds is done strictly by eye, without the convenient mechanical benefit of the square as was the case of two-piece molds.

The first step in locating parting lines on a complex

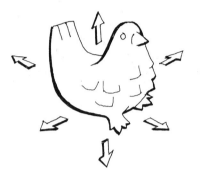

Fig. 58. The model must be studied for six major withdrawal directions.

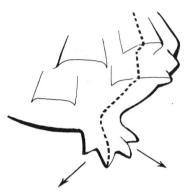

Fig. 59. Details provide clues as to how the sections must withdraw.

model is to realize that every model must eventually rest on something, and that every model, therefore, usually has a bottom or base and this bottom is usually flat. Consequently, this is where one begins, by sitting the model on its base upon the work surface.

The next step is to also realize that there are four basic horizontal directions of withdrawal possible from the model, all being 90° apart: front, back, and two sides; there are also two additional vertical directions: from the top and from the bottom (Fig. 58). The model is looked at in terms of the four horizontal directions, evaluating the general mass areas of the piece as they relate to withdrawal of large areas without turning corners.

The model is turned back and forth and mental note is made of the points where the surface of the mass changes direction and thus might be relegated to an adjacent section of the mold. Then the mold is examined more closely for features that could possibly be undercuts: crevices, bulges of bone, folds of clothing, etc. — in other words surface details. The shape and direction of these details give us more specific clues as to how the mold must withdraw to clear them (Fig. 59).

Once the horizontal directions have been checked, the top and bottom directions of withdrawal are considered. Relating the directions of the details to the general direction of the mass withdrawal, we form in our minds a fairly good idea of how the mold will have to separate. This study is not a quick one; the model must be repeatedly turned, and tentative pencil lines are drawn along what look to be the logical high points. The goal is always the same: unimpeded withdrawal while attempting to keep the number of sections to a minimum.

Let us take, for an example, the rhinoceros model of Figs. 60 and 61. As we examine the model, the first question is: Can this be made in a two-piece mold? Considering its large masses, it could feasibly divide much like a sphere, either top and bottom or left and right, since it is well-rounded and has a flat base. So we look at the details, and we are immediately struck with the complexity of the facial area, including the ears and horn. We plan to remove the ears in order to simplify the area. (See Chapter 8 on appendage removal.) We cannot remove the horn because it is too much a part of the flowing design and would be awkward to rejoin. Even with the ears removed,

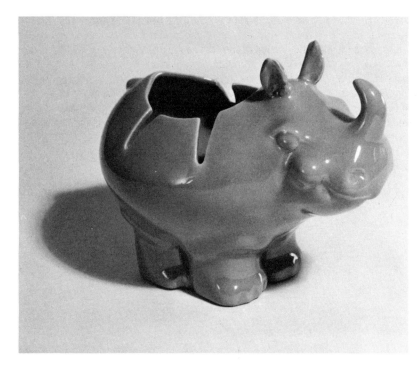

Fig. 60. Model, front view.

Fig. 61. Model, rear view.

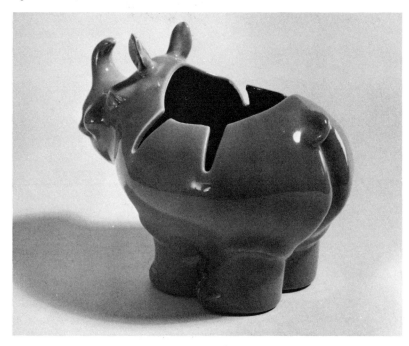

the curve of the horn (Fig. 62) prohibits withdrawal from the top, thus eliminating the possibility of a two-piece mold working from that standpoint. With top and bottom withdrawal ruled out, we evaluate the side withdrawal.

We see the indentations of where the legs curve inward and meet, not only on the sides but also in the front and rear (Fig. 63). This means that the mold must divide so as to easily withdraw from those four indented areas (Fig. 64). Therefore, the parting line must fall on the outside curve of each leg (Fig. 65). This tells us that not only is a two-piece mold out of the question, we have a four-piece mold as a minimum.

Starting, then at the base, we draw a line up the outside curve of each leg to the body (Figs. 66 and 67). The two lines from the front legs (line *b* and *c*) can each be brought up along the lower jaw of the head. The head itself, with the ears removed, can be split with one line running right down the center of the forehead, up and around the horn, and down to the mouth area (line *a*), where it can join the two lines from the front legs and lower jaw (detail, Fig. 68). By splitting the head this way, we can clearly withdraw from the eyes and cheeks without undercutting. We also see that the front section can form the mouth, chin, and inside area of the front legs in one piece (Fig. 66).

So only the rear area remains to be resolved and, since it is a very simple rounded form, the parting lines run up the outside of each rear leg and up over each buttock to the top trim (Fig. 67). The model is now divided into four sections: a withdrawal to the front, one to each side, and one to the rear.

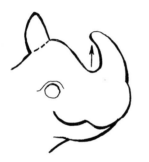

Fig. 62. Horn prohibits top withdrawal.

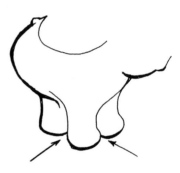

Fig. 63. Indentations at legs limit withdrawal possibilities.

Fig. 64. Bottom view of the legs shows the direction of withdrawal possible for each indentation.

Fig. 65. Parting lines must fall on outside curve of each leg, dividing the mold into four sections.

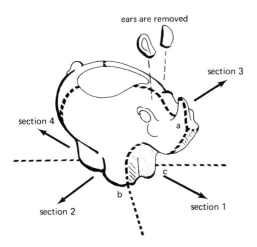

ears are removed

section 3

section 4

section 2

section 1

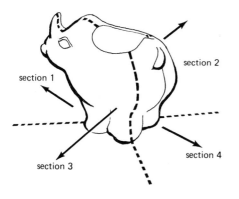

section 1

section 2

section 3

section 4

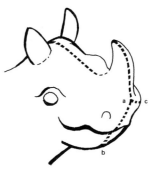

Fig. 66. (Left) Parting lines drawn up each leg divide the mold into left, right, front, and rear withdrawal. Ears are removed to simplify mold.

Fig. 67. (Left below) Rear view; final result is a four-piece mold.

Fig. 68. (Below) Detail of face shows how lines from front legs (*b* and *c*) meet line dividing the head (*a*).

SUMMING UP

It would be very convenient if the parting lines of a multi-piece mold always fell along the most prominent features of a model, but we have seen this is not the case. Each situation is different and only the general principles of draft, undercuts, and angles of withdrawal can be relied on to guide you. Always try to keep the number of sections to a minimum. Start with simple models and make some actual molds, following the steps described in the next chapter. It will all become much clearer as you gain empirical experience. Special problems such as casting sequence, locking principle, and stand-off members (arms and legs, etc.) are discussed in Chapter 8.

6. Making the Piece Mold

The key to making molds, providing that the parting lines are correctly drawn, is the physical blocking off of all areas of the model except the one we wish to cast. This blocking off may be accomplished with either clay or plaster, and it enables us to cast one section of the mold at a time, precisely and efficiently. Whether we use clay or plaster for blocking off depends on the number of sections to be cast and on the regularity of the parting line.

In casting a two-piece mold of a model with an undulating parting line, we use clay to block off half of the model, usually the half that will produce the thinner section of the mold. In effect, the model is partially submerged (hidden) in a bed of clay, which is called a clay build-up (Fig. 69). We then erect retaining walls around both the submerged portion of the model and the exposed portion to form our casting area of the model section above the clay bed. When that area has been cast, we use the resulting mold section in turn to block off the other half of the model and form our second casting area.

In casting a two-piece mold of a model with a perfectly straight parting line, however, we use a level piece of plaster called a plaster build-up to surround the model and block off half of its form from the casting area (Fig. 70). Once the plaster build-up has been formed, or once the clay bed has been constructed, there is essentially no difference in the remaining casting procedures.

In casting a mold of more than two sections, we follow a slightly more complex system of blocking off with clay all sections of the model except the one to be cast and then unblocking each new section separately, in the sequence in which it is to be cast (Fig. 71). The same boarding-up and pouring procedures are followed for multi-piece molds as for two-piece molds. But, as the casting sequence entails some additional knowledge of mold-making principles, we shall examine molds of three or more pieces in a separate chapter. A familiarity with the procedures for making two-piece molds will provide a firm foundation for subsequently casting molds of more than two pieces.

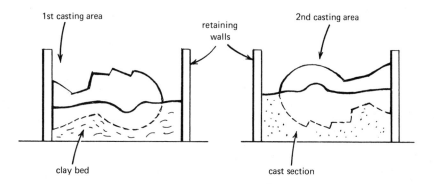

Fig. 69. Exposed area of model in clay bed is cast first. Unit is inverted and clay bed is removed to expose second casting area.

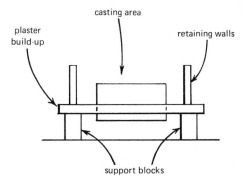

Fig. 70. Level plaster build-up surrounds model with straight parting line and blocks off the lower half of the model so top half can be cast.

Fig. 71. Multi-sectioned molds are made by unblocking each section to be cast in sequence.

THE CLAY-BED METHOD

Positioning the Model

In Chapter 5, we saw that to find the parting line we could tilt and position the model at nearly any angle to acquire clearance for undercuts before delineating the line with the square. Once we have found and drawn the parting line, we again must position the model — this time for casting a mold section. This position may be quite different from that used in finding the parting line.

In positioning the model for mold-making, we attempt to do two things. One is to make the model's base either perpendicular or parallel to the work surface — one position or the other but not in between. In either case, when the mold is completed and ready to be filled with clay slip, we will be able to place the base of the mold in a horizontal, level position in order to fill it without trapping air. The second condition we try to meet at the same time is to keep the parting line in a horizontal position. This would enable us to withdraw the two mold sections at a perpendicular angle to the work surface.

Most models allow these two simultaneous mold-making requirements to be fulfilled with the parting line at least approximately horizontal. The question of whether the base is to be placed vertically or horizontally then depends on how the mold is to separate. If the mold is to separate into a front and back, then the base is vertical; if the mold is to separate into a top and bottom, the base is horizontal, that is parallel, to the work surface (Fig. 72).

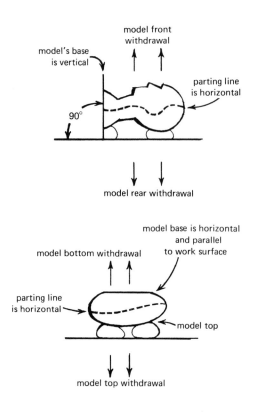

Fig. 72. The model's base may be placed either horizontal to or perpendicular to the work surface, and the parting line should be horizontal, enabling mold sections to be withdrawn at a perpendicular angle to the work surface.

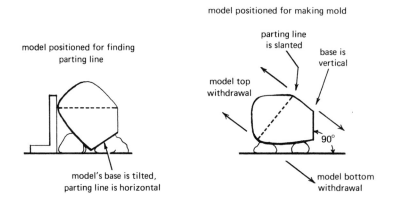

Fig. 73. In some cases, the parting line must be placed at an angle in order to keep the base vertical (or horizontal) to the work surface. Mold withdrawal will no longer be perpendicular to the work surface.

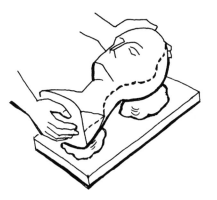

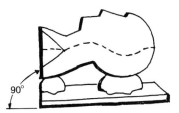

Fig. 74. Seat model on clay with parting line approximately horizontal. Model may be rotated so draft of first section is straight up, but base must remain vertical.

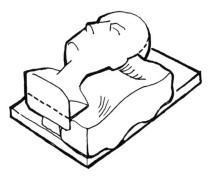

Fig. 75. Build up clay to parting line.

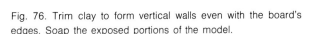

Fig. 76. Trim clay to form vertical walls even with the board's edges. Soap the exposed portions of the model.

There are situations, of course, where it is not possible to meet both conditions. In these cases, it is more important to have the base horizontal or vertical than it is to keep the parting line horizontal (Fig. 73). This means that the mold sections will no longer withdraw at a perpendicular angle to the work surface. In most cases, however, each section will still withdraw at an angle perpendicular to the parting line. The slanted withdrawal direction is always one of opposites — if the top mold section withdraws at an angle of 30° from the work surface, the bottom section will withdraw at a 30° angle in the opposite direction. Before considering such cases, we will first examine the more usual situation of casting a mold with the parting line of the model generally horizontal and with the base vertical to the work surface.

The Clay Build-Up

The first step is to position the model on a level surface with the base vertical and the parting line approximately horizontal. Use a soaped board of ¾-inch plywood as the surface and place several chunks of soft clay on the board

to cushion the model. The board, which will enable you to move the model about on the work surface as you build up the clay, should be about 2 inches larger all around than the model is when positioned on it.

With its parting line approximately horizontal to the board, place the model on the clay cushion. Shift the clay and maneuver the model so that the draft of the section to be cast is straight up, at a 90° angle to the work surface (Fig. 74). While positioning the model, look down at it from directly above. If the model's position is correct, you should be able to see every surface that has been planned for this section. If any portion is hidden from view, rotate the model so that every surface of the section to be cast can be seen. The base must remain vertical, however.

Next build up soft clay around the model on all sides until you reach the parting line (Fig. 75). With suitable tools, smooth the clay bed surrounding the model into a flowing, continuous surface that follows the parting line and extends out to the edges of the board. Trim off any excess clay so that the vertical walls of the clay bed are even with the edges of the base board (Fig. 76). This bed is called the build-up.

41

Fig. 77. Place soaped boards against the clay walls and cast plaster into the form to a height of 1½ inches above the exposed model's highest point.

Casting the Two Mold Sections

When the clay build-up is complete, soap the model as described in Chapter 3. Then soap four boards and place them against the clay walls to form a box around the unit (Fig. 77). On one board, make a casting mark 1½ inches above the highest point of the model. Seam and clamp the boards as described in Chapter 3. Mix the plaster and pour it into one corner of the boxed form so that it flows up and over the model, until it reaches the casting mark. Gently shake the table or tap the side of the boards to bring air bubbles to the surface. Screed the plaster. Once set, this is the first section of the mold.

After the first section has set, carefully unclamp and remove the four boards, and lift the whole remaining unit — plaster, model, and clay — to an inverted position so that the plaster section is on the bottom, resting on the work surface (Fig. 78). Remove the base board and the built-up

Fig. 78. When plaster has set, remove the boards and invert the entire unit so the cast section is resting on the marble.

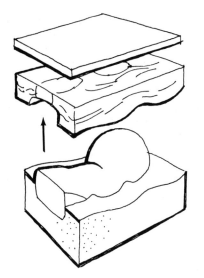

Fig. 79. Remove the base board and the clay build-up.

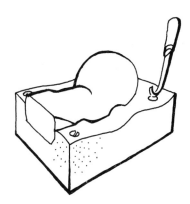

Fig. 80. Cut small, round depressions as keys in the completed plaster mold half.

Fig. 81. Mold sections require keys for perfect reassembly.

Fig. 82. Key-cutting knife has curved blade.

clay bed, leaving the plaster section and the model intact (Fig. 79). Cut a round depression in each of three corners of the plaster cast to act as keys (Fig. 80). These depressions allow the plaster that will be subsequently cast against the first mold section to flow in and form bumps upon hardening. When the sections are then separated and reassembled for casting, the bumps will seat themselves in their respective depressions (Fig. 81) and make alignment of the sections perfect.

The depressions can be cut with a spoon or other rounded instrument or with a key-cutting knife, which has a curved blade (Fig. 82). The keys should then be sanded

43

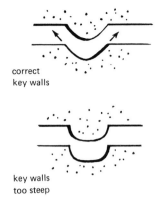

correct
key walls

key walls
too steep

Fig. 83. Correct and incorrect key profiles.

smooth so as not to undercut. The walls of the depression should be tapered and not cut too deeply (Fig. 83) so that the positive part of the key will not be locked in. Correctly angled keys are especially important when made in adjoining walls of a mold section (Fig. 84).

When the keys have been cut, soap the exposed areas of the model and soap all surfaces of the mold section already cast — top (including keys), sides, and bottom (in case there are leaks). To cast the second section of the mold, place soaped casting boards against the walls of the first mold section, forming a box around the unit (Fig. 85). Seam and clamp the boards; mix the plaster and pour it into the boxed form as before, up to the 1½-inch casting mark.

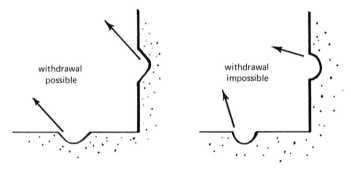

withdrawal
possible

withdrawal
impossible

Fig. 84. Correct angling of key walls is crucial on mold corners.

Fig. 85. After cutting the keys, soap the mold section and the newly exposed areas of the model. Place soaped boards against the walls of the mold and pour plaster to 1½ inches above the model's highest point.

1 ½″

Fig. 86. The completed mold.

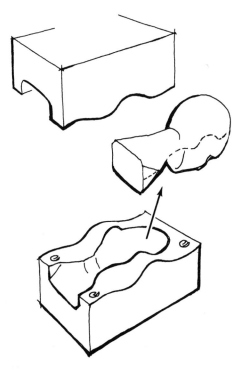

Fig. 87. Open the mold and remove the model.

Fig. 88. To reassemble the mold for casting, use rubber loops or metal clamps.

Remove the boards and clay, and the mold is complete (Fig. 86). Separate the two halves of the mold and remove the model (Fig. 87). Clean up the inside of the mold, removing any small irregularities or feathered edges of plaster that may have occurred. If the original model was of clay, all traces of material that may have stuck to the plaster must be removed. When soaped and clamped or tied, the finished mold is ready to be used for casting (Fig. 88). (The mold is not soaped for slip-casting.)

45

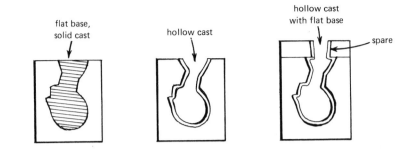

flat base, solid cast

hollow cast

hollow cast with flat base

spare

Fig. 89. Mold on right shows spare must be incorporated to cast a hollow model with a flat base.

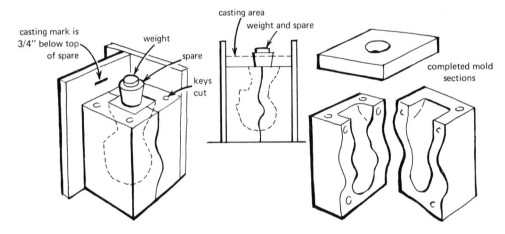

casting mark is 3/4" below top of spare

weight

spare

keys cut

casting area

weight and spare

completed mold sections

Fig. 90. Plaster plug is weighted down on base of model and a third mold section is cast on one end of the other two sections. This provides an opening for casting.

The Spare

The mold just described would produce a solid plaster cast quite nicely. However, if the cast were to be hollow instead of solid, which would be the case if the casting material were clay slip (liquid clay), and if a flat base were desired, the mold would have been designed to incorporate a pouring opening called a spare (Fig. 89).

When a solid cast is made, the material fills the mold completely and, upon hardening, it forms a flat surface flush with the part of the mold that is left open for pouring. When a hollow cast is made, however, the opening is left open, to allow excess casting material to be poured out, and no flat surface is formed. In order to form a base, the mold must be made to include the bottom surface of the model and still provide an opening for pouring. This is done by adding a plug of plaster or clay, also called a spare, to the base of the model when the mold sections are made.* In this case, the spare is added by casting a separate mold section of the base, with a plaster plug weighted down on top of it, after the first two mold sections have been made (Fig. 90). In other cases, as you will see in Chapter 8, the spare may be incorporated into the mold when the clay bed is formed and it may be located elsewhere on the model, not necessarily at the base.

The size and shape of the spare are variable (see page 60). Most often the spare takes the form of a truncated cone. Generally, as the diameter of the spare increases, the height decreases; it is better to have a short, wide spare than a tall, narrow one, because the tall one necessitates that the mold be that much thicker at that point (Fig. 91).

*To clarify our future use of the term "spare," we will use it in this book to refer to the pieces of plaster or clay used in forming the opening and not to the opening itself, although in pottery the term is used in both senses and also refers to the clay that is formed in the mold opening and is trimmed away.

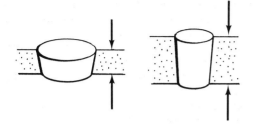

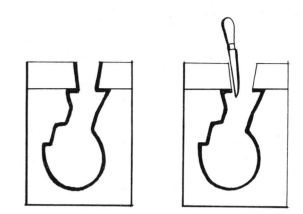

Fig. 91. (Above) A shorter spare is preferable because it requires less mold bulk.

Fig. 92. (Right) Wall of clay formed in the spare opening is trimmed when clay is proper thickness for the cast.

After the piece has been cast through the opening in the mold provided by the spare, the wall of clay formed in the opening is merely trimmed away with a knife (Fig. 92).

Horizontal Base

When the model's base, as well as its parting line, is in a horizontal position, the clay bed is formed in exactly the same way as just described but it is built out to completely encircle the model. The four retaining walls are erected flush against the clay walls and the first section is cast level with the plane of the model's base, if no spare is used, or it is cast to within ¾ of an inch below a spare added to the base (Fig. 93). The second section is cast by inverting the first mold section, erecting four retaining walls and pouring plaster to a mark 1½ inches above the model's highest point (Fig. 94).

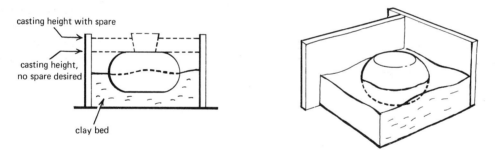

Fig. 93. When model's base and parting line are both horizontal, clay bed completely encircles model. Base section may be cast with or without a spare.

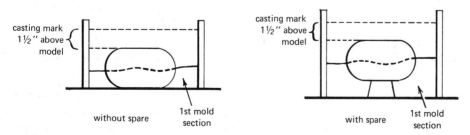

Fig. 94. In either case, the second section is cast to a height of 1½ inches above the model's highest point.

Angular Withdrawal

When the model is positioned for casting so that its base is vertical or horizontal but its parting line slants, it will not be possible to see the surfaces planned for the mold section by looking at the model from directly above, that is, at an angle perpendicular to the work surface. If the parting line was generally horizontal when drawn, however, these surfaces should be visible when viewed from above at an angle perpendicular to the parting line (Fig. 95). This angle, which assures clearance of undercuts, is the angle at which the mold section will be withdrawn.

The clay bed and the retaining walls are used in exactly the same way as before (Fig. 96). The outside appearance of the mold, therefore, is the same as previous molds, with straight, vertical walls. To preclude any attempt at opening the finished mold vertically, which could damage the interior edges of the mold, the outside walls should be clearly marked with arrows indicating the proper angle of withdrawal (Fig. 97).

In cases where the parting line was slanted when drawn, sighting for draft must again be done at the intended angle of withdrawal, though that angle is not perpendicular to either the parting line or the work surface (Fig. 98). Here, too, the mold sections must be marked with the angles of withdrawal (Fig. 99).

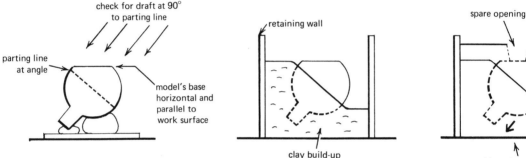

Fig. 95. If the parting line was horizontal when drawn but is at an angle to the work surface for casting, mold sections will withdraw at a 90° angle to the parting line. Check draft by viewing the model from that angle.

Fig. 96. Clay build-up for angled parting line.

Fig. 97. Mark outside walls of mold sections with arrows showing angle of withdrawal.

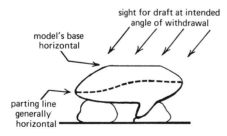

Fig. 98. If parting line was slanted when drawn and is horizontal for casting, sighting for draft must be done at the intended angle of withdrawal. This angle is not perpendicular to either the parting line or the work surface.

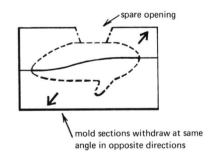

Fig. 99. Mold sections must be marked with arrows showing the angle of withdrawal. Each section withdraws at the same angle to the work surface but in opposite directions.

THE PLASTER BUILD-UP METHOD

It can readily be seen that if a build-up is to follow an irregular, sinuous parting line, the clay build-up is the most appropriate, since it can be manipulated to form an undulating surface. If, however, the parting line is a *straight* line, the model would call for a build-up that is a flat plane. In that case, it would be a waste of effort to laboriously build up a bed of clay; it is much more feasible to create the build-up from an already-flat material. For this reason, we cast a separate, flat *plaster build-up;* this is easily made, takes a fraction of the time that a clay build-up requires, and also gives a beautiful marble-smooth surface to cast against, helping to keep the subsequent mold neat and level.

Making the Plaster Build-Up

If you have a model (Fig. 100) that can be divided, using the square, into two symmetrical halves, the parting line is a straight line. The first step in making the mold is to make the plaster build-up. Soap the model and, using soft clay to cushion it, place the model on a soaped work surface (preferably marble) with the parting line approximately horizontal.

Adjust the arm of a surface gauge to align with the axial center of one end of the model. Move the gauge to the opposite end and raise or lower that end of the model until its axial center aligns with the undisturbed tip of the gauge arm. Both ends of the model are now the same height above the work surface and the model is therefore truly horizontal (Fig. 101). With the square, check to see that the flat plane of the model base is vertical (Fig. 102), as it should be if the positioning with the surface gauge was correctly done. (If you do not have a surface gauge, you can use the square to position the opposite ends of the model, measuring and adjusting their heights above the work surface so that they agree.)

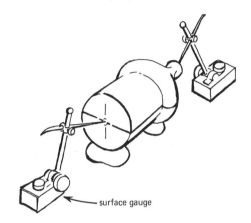
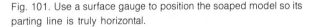
surface gauge

Fig. 101. Use a surface gauge to position the soaped model so its parting line is truly horizontal.

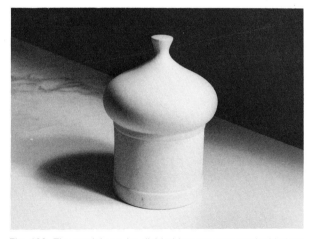

Fig. 100. The model can be divided into two symmetrical halves with a straight parting line.

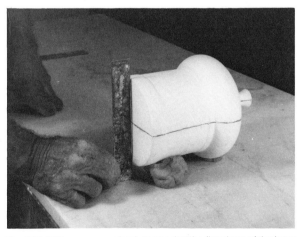

Fig. 102. With a square, check to see that the flat plane of the base is vertical.

49

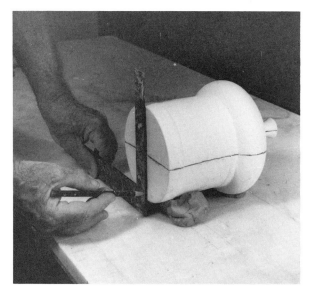

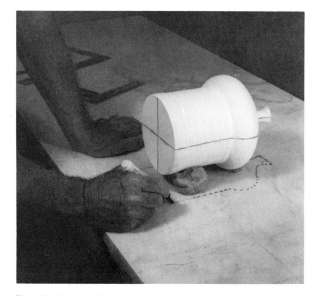

Fig. 103. Draw a vertical line through the center of the model's base.

Fig. 105. Use indelible pencil or ink to mark the dots.

Fig. 104. Guided by the square, mark the outline of the model's form on the work surface. Then draw a second dotted line ⅛ to ¼ of an inch away from the first outline.

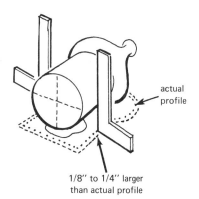

actual profile

1/8" to 1/4" larger than actual profile

Draw a vertical reference line through the center of the model's base so that the model can be removed and replaced in its exact relative position (Fig. 103). With the vertical arm of the square touching the model and the horizontal arm touching the work surface, move the square around the model and mark a series of dots on the *work surface* to coincide with the points touched by the corner edge of the square (Fig. 104). This produces an exact outline of the model on the work surface. What we need, however, is a profile slightly *larger* than the model; so the next step is to draw a second series of dots between ⅛ and ¼ of an inch away from the first series (Fig. 104). Use indelible pencil or ink (Fig. 105). The larger profile will allow a clearance for the build-up to easily be slipped over the model.

Fig. 106. Connect the dots to obtain the model's profile and draw a rectangle around the profile 2 to 2¼ inches from its widest points.

When the second series of dots has been marked, remove the model, placing it to one side, and connect these dots with indelible pencil. At the same time, draw a rectangle on the work surface around the model's outline at a distance of 2 to 2¼ inches from the profile's widest points. To assure right-angled corners, use the square (Fig. 106).

On a separate area of the work surface, place a chunk of soft clay and roll this into a cylinder approximately 1½ to 2 inches in diameter (Fig. 107). With a knife, flatten the cylinder to form a thick ribbon of clay (Fig. 108). Place this clay ribbon vertically on the work surface to form a wall at least 2 inches high around the inside contour of the drawn model, bracing the walls with small pieces of clay within the

Fig. 107. Roll some soft clay into a cylinder.

Fig. 108. Flatten the clay cylinder into a rectangular ribbon.

contour (Figs. 109, 110, and 111). Place soaped boards to form a box around the drawn rectangle and make a casting mark on one board from 1 to 1½ inches above the work surface (Fig. 112). The area of the work surface between the clay wall and the boxed form is the area to be cast, so make certain you have soaped it (Fig. 113).

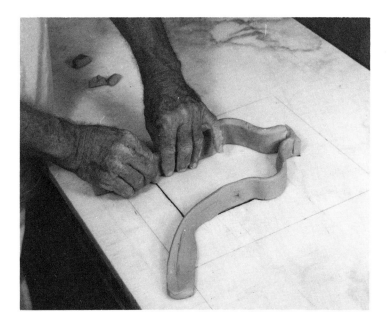

Fig. 109. Place clay walls within drawn profile of the model.

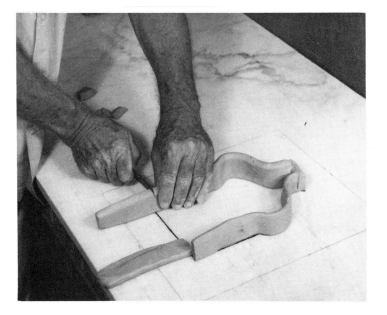

Fig. 110. Trim ends of the clay wall.

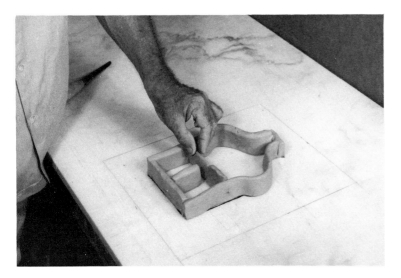

Fig. 111. Brace the walled contour with small bits of clay.

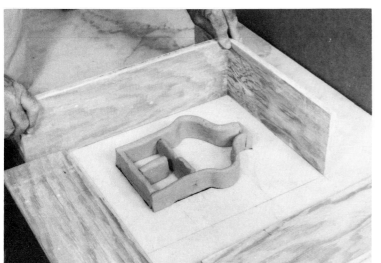

Fig. 112. Place soaped boards on the drawn rectangle around the model's profile.

Fig. 113. Soap the casting area outside the walled profile. Pour plaster to the casting mark 1 to 1½ inches above the work surface.

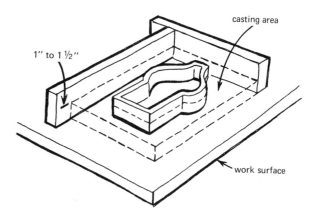

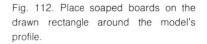

1″ to 1½″

casting area

work surface

Seam and clamp the boards and pour plaster into the casting area to the indicated height. When the plaster has set, remove the boards and the clay walls (Fig. 114). This cast piece is the plaster build-up, which should now be scraped on its top surface to remove any imperfections (Fig. 115). The side cast against the work surface will be perfectly smooth. By inverting the build-up to this side and positioning it over our model, we obtain a marble-smooth surface that is both square and level, making all subsequent steps much easier and more accurate.

Fig. 114. When plaster has set, remove the boards and clay walls.

Fig. 115. Smooth the top surface of the plaster build-up with a scraper.

Fig. 116. Place support blocks to hold the build-up in position.

Fig. 117. Invert the build-up to its marble-smooth side and soap it. Slip it over the soaped model and rest it on the support blocks.

Fig. 118. Adjust the blocks and the build-up so the build-up's top surface is level with the parting line on the model. If necessary, use shims of plaster, cardboard or wood with the support blocks.

Using the Plaster Build-Up

Clean the work surface and resoap it, or soap a large plywood board on which to locate the model, cushioned again with soft clay. If the model is made of clay, it is not necessary to soap it; if it is made of plaster, be sure to soap it thoroughly before positioning it. Again, the parting line must be horizontal. Place small blocks of plaster around the model to act as supports for the plaster build-up, which will be positioned over the model so it is parallel to the parting line (Fig. 116).

Invert the build-up so that the marble-smooth side is up, and soap the top surface, plus the inside and outside edges. Carefully slip the build-up over the model and rest it on the plaster blocks (Fig. 117). With shims, adjust the height of the plaster blocks so that the top surface of the build-up is aligned with the parting line on the model (Fig. 118). Use a small bubble level to make sure the top surface is both level and in correct alignment with the line on the model.

Fig. 119. Draw a rectangle on the build-up 1½ inches away from the model's widest point.

Fig. 120. Wedge clay into the small space between the build-up and the model.

When the surface is level, draw a rectangle on the build-up at a distance of 1½ inches from the model's widest points. Use a square to assure true corners (Fig. 119). This rectangle indicates where the boards will be placed to form the casting area. The boards are placed on the *build-up,* not on the work surface, to allow for secure claying up along the bottom seams and to better support the weight of the poured plaster. Note that in this case the build-up surrounds the model completely and this method is preferable so that all four boards may be placed on the build-up. This means that the entire base of the model will be included in the mold and that an opening will have to be

provided by adding a spare to another part of the model. If the pouring hole must be located at the base of the model, the build-up must be left open at that end and one board would then be set on the work surface so that it was flush against the model's base.

Once firmly placed in a level position, the build-up provides a splendid platform to cast against. First, however, the slight gap between the top surface of the build-up and the adjoining surface of the model must be filled with soft clay wedged into the crevice (Fig. 120). The clay is then smoothed flush with a small piece of rubber tile to form a clean intersection of surfaces (Fig. 121). To

insure against leakage, it is wise to wedge an additional roll of clay around the *underneath* side of the crevice. Use a modeling tool to reach under the build-up if necessary. An additional precaution that is usually taken by professionals is to cut a chamfer edge around the opening in the inverted build-up. This helps seat the clay when it is wedged into the seam between the model and the build-up (Figs. 122 and 123).

Fig. 121. Smooth the seam.

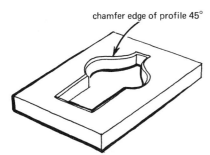

Fig. 122. Chamfer edge may be cut on the profile to help seat the clay.

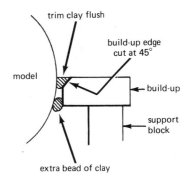

Fig. 123. If desired, wedge extra clay in the space between the build-up and the model on the underneath side.

Fig. 124. Place soaped boards around the drawn rectangle on the build-up.

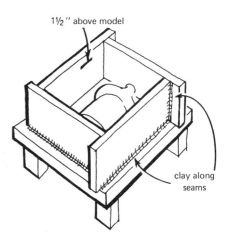

Fig. 125. Clay and clamp the boards. Make a casting mark 1½ inches above the model's highest point.

Place soaped boards around the rectangle you have drawn on the build-up to form the casting area (Fig. 124). Clay up the seams and firmly tie or clamp the box together. Then, mark a spot on one of the boards 1½ inches above the highest point of the exposed model half (Fig. 125). This is, as before, the height desired for the cast. Estimate how much material it will take; then mix plaster accordingly.

Pour the plaster into one corner of the boxed form and let it flow freely up and over the model. When the mark has been reached (Fig. 126), stop the pour and gently shake the table or tap the sides of the boards to bring the air bubbles to the surface and screed the top. After the plaster has firmed up, remove the clamps, clay seams, and four boards, and trim off any excesses of plaster with a straightedge and knife.

When the plaster has cooled, carefully lift and invert as a unit the newly poured mold half with the model and with the build-up still in place (Fig. 127). If any clay or shims have stuck to the model or build-up, remove them carefully. Then remove the plaster build-up and clean away all traces of clay seam along the parting line (Fig. 128). Using a small scraper and taking care not to nick the model, also smooth any bumps in the plaster just cast, especially in the area that was seamed by clay. With a curved knife, cut three or four keys in the mold half (Fig. 129). This completes one half of the mold.

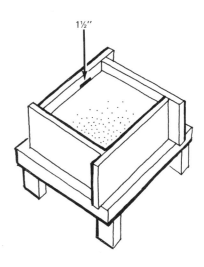

Fig. 126. Pour plaster to the casting mark.

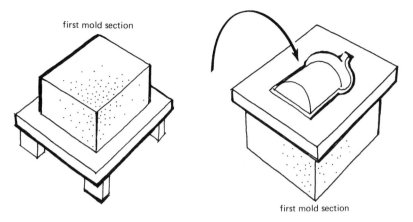

first mold section

first mold section

Fig. 127. When plaster has set, remove the boards and invert the build-up, model, and cast section as a unit.

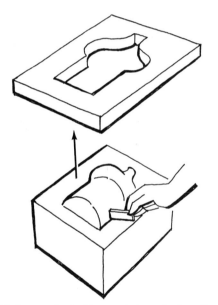

Fig. 128. Remove the build-up and clean clay from the seam.

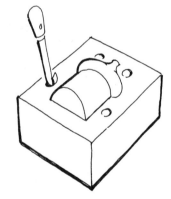

Fig. 129. Cut keys in the first mold section.

Making the Second Mold Section with a Spare

As in the clay-bed method, the keyed mold half already cast and the exposed half of the model within it form a unit, with the completed mold section now blocking off all areas of the model except the one we wish to cast. And as before, the simple sequence of steps now is to soap every exposed surface of this unit; enclose the unit in a boxed form, with vertical walls set flush against the first mold section and extending high enough to make a casting mark at least 1½ inches above the highest point of the exposed model; and pour plaster into the casting area. However, since we have not used the base of the model to form the mold opening, we have an additional factor to consider and that is the location of the spare.

As mentioned previously (page 46), the spare is not always located at the model's base. The decision on where to locate the spare is made according to how the final product will be cast. In this instance, we desired a slip-cast model of the minaret with a completely flat bottom. This

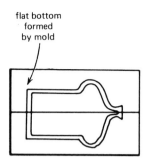

Fig. 130. To form flat bottom of hollow cast minaret, spare must be located elsewhere on the model.

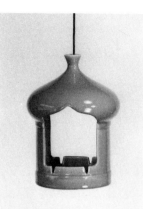

Fig. 131. Design calls for openings in the front and rear surfaces of the slip-cast form.

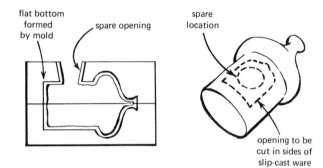

Fig. 132. Spare is therefore located on one of the surfaces to be cut out after the form has been cast.

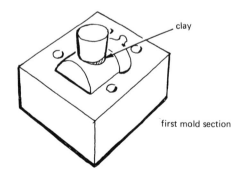

Fig. 133. Use clay to fill gaps between the plaster spare and the model's surface.

meant that the spare could not be located at the model's base (Fig. 130). However, the design also called for openings to be cut by hand into the front and rear surfaces of the minaret after the entire clay form had been cast (Fig. 131). (As the cast is a hollow one, openings may quite easily be cut by hand into any of the thin, clay walls while the clay is still soft.) The logical location for the spare, therefore, was on one of the surfaces to be removed after slip-casting (Fig. 132). We also chose a suitable size and shape for the spare.

A tapered, cylindrical spare is employed most often because it allows the long-bladed trimming knife to be used in one, continuous motion. Spare shapes that are not round require more care in the trimming operation and have a tendency to wear at the corners. The size of the spare, that is, its diameter, is determined by its location. In this case, the spare had to be smaller than the openings that were to be hand-cut in the slip-cast ware, but large enough to allow quick filling and draining.

Plaster spares can be shaped by using a coddle and turning the form on the wheel (page 100); or clay spares can be formed by hand.

Calculating the location, shape and size of the spare is all a natural part of the original analysis of the model. But this subject, like that of determining the parting line, contains so many variables that the inexperienced mold-maker can learn only by studying each particular example in its own context. The guideline for determining the location of the spare is that it be placed where it will leave the neatest possible casting hole while at the same time allowing the mold to be filled without trapping air. Usually, this location is at the base of the model, but when a complete, flat base is desired the mold-maker must find another suitable location. Additional information on the location, size and shape of the spare is on pages 65, 69, and 87 to 94.

To incorporate the spare into the second mold section, place it upright on the model's surface. If the spare is plaster, soap it first and fill in any gaps between the spare and the model's surface with soft clay (Fig. 133). As a precaution, to prevent its floating in the liquid plaster, place a small weight on the spare. Then place the soaped boards around the mold section containing the model. The boards must be high enough to include the spare. Make a casting mark ¾ of an inch below the top of the spare. This is to

leave enough of the spare exposed so that it may be grasped with the fingers (Fig. 134). Clay and clamp the boards in position. Pour the plaster into one corner of the boxed form as before. When the plaster has set, remove the clamps and boards (Fig. 135).

Remove the spare and lift the top mold section off. Then remove the model from the bottom section of the mold (Fig. 136). If any difficulty is encountered in separating the mold halves, gently tap each section with a rubber hammer (see Chapter 12).

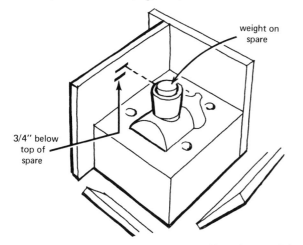

Fig. 134. Weight the spare and place soaped boards around the first mold section and the model. (All plaster surfaces should also be soaped.) Make a casting mark ¾ of an inch below the top of the spare. Pour to the mark.

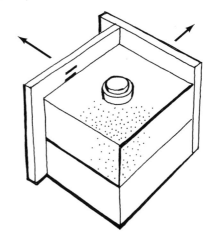

Fig. 135. When plaster has set, remove the boards.

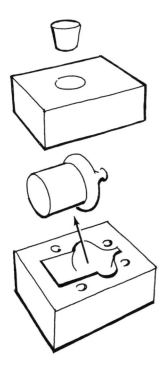

Fig. 136. (Left) Remove the spare and open the mold to release the model.

Fig. 137. (Below) The completed mold sections. Two corners have been sawed off for easier handling — see Chapter 12.

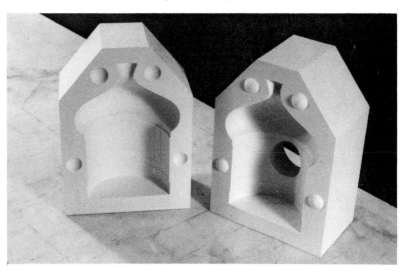

7. Multiple Mold Requirements: The Block and Case and Production Molds

Up to now we have been concerned with the basics of making a mold that can be used to reproduce the model in limited quantities. This is not to say that we cannot make a good number of casts from the mold, but the mold will eventually produce less accurate casts and finally become unusable. In addition, if we wished to produce the model in large quantities, it would certainly be more efficient to make more than one casting at a time. This means that we would need several molds of the model instead of just one. Duplicate molds are called production molds and they are usually obtained not from the model, but from the original mold of the model (called the model mold).

In order to do this, we need to separate the model mold into its various sections and to treat each of these sections as new subject matter from which we cast a separate mold.

The mold that we make of each section is called a *block and case*. The *block* is a positive form; it is cast in the negative cavity of the model-mold section. The *case* completes the mold by forming the outside walls of the model-mold section. When assembled with the case fitting on the block, the two components form a complete mold which can be cast into to duplicate the model-mold section. It is necessary to make a block and case for each section of the model mold. Once the blocks and cases have been made, each set is assembled and cast into as many times as required to obtain the desired number of production molds (Fig. 138).

As a term, block and case always refers to the special mold used to duplicate a mold section. The block is the portion of the mold which corresponds to the *inside* of the

Fig. 138. The sequence of steps begins with a mold of the model (I). A positive form called a block is cast for each section of the original mold (II), and retaining walls are made to form a case for each block (III). Each assembled block and case is used to obtain a section of the production mold (IV).

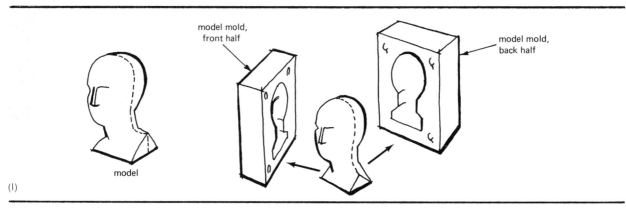

model mold,
front half

model mold,
back half

model

(I)

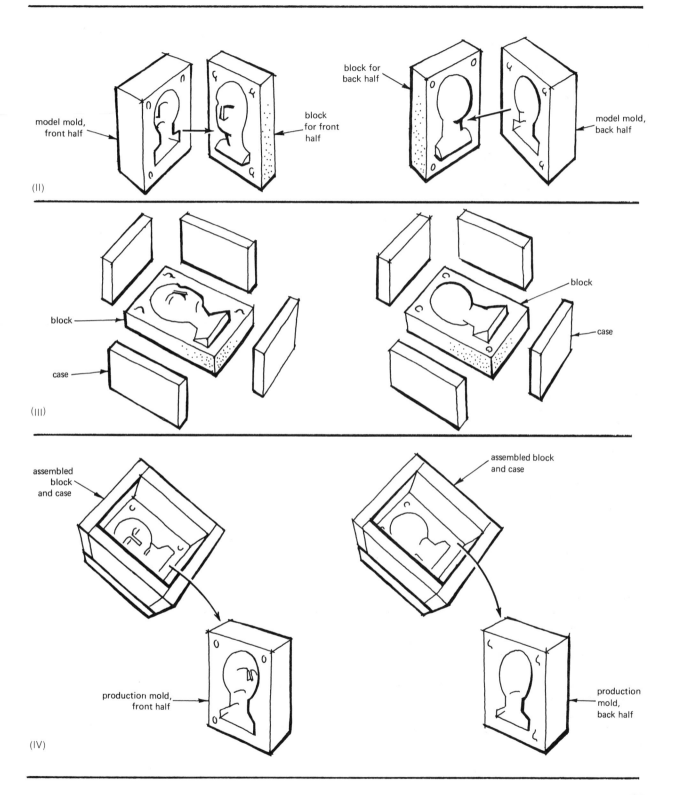

model mold, front half

block for front half

block for back half

model mold, back half

(II)

block

case

block

case

(III)

assembled block and case

assembled block and case

production mold, front half

production mold, back half

(IV)

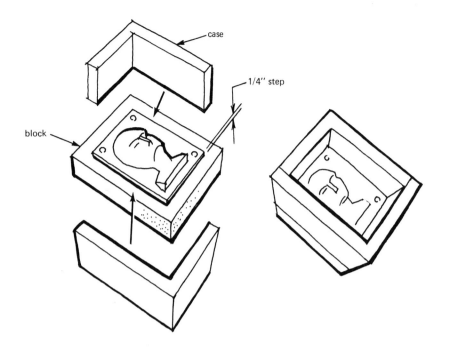

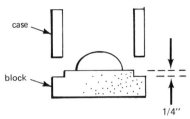

Fig. 139. To simplify handling, the case is usually made as two L-shaped members and the block is made with a step to accommodate the case members.

original model mold and thus forms the *inside* of the production mold. The case is the portion which forms the *outside,* or walls, of the production mold.

The unit of the block and case is a special mold in several ways: First, its walls and base disassemble completely. The block, or bottom section, is always made of a low-expansion gypsum, usually Hydrostone or Ultracal, so that the size of the positive reproduction is very close to the size of the original model. As the case forms only the external surfaces of the production mold, it is made of plaster. The case is usually made as two L-shaped members, rather than as four walls, to simplify handling (Fig. 139). In addition, the block is made with a recessed edge or step in its top surface to aid in positioning the case.

With the block and case, we come to the end of a chain of integral, interrelated links. Starting with the model, we analyze it to determine how the mold sections can best be divided. By blocking off with clay, we cast each mold section in its turn and obtain a model mold. From the model mold, we produce a block and case for each section, and from each block and case we produce a section of the production mold, which enables us to cast as many reproductions of the original model as we desire. On the following pages, we will review all the necessary steps as we examine in detail the procedures for making each block and case.

FINDING THE PARTING LINE

Examine the model (Fig. 140) for possible directions of withdrawal. Here, we discard any attempt at a top and bottom withdrawal because we see that the projections of the feet from the body would not permit this. We also discard withdrawal to either side of the form because each mold section would embrace the curve of a front leg. We therefore decide on a front and rear withdrawal. We estimate that the parting line will run across the top of each ear and down each side of the frog's body to the base, with the rear section of the mold forming a larger portion of the frog.

With this evaluation fairly certain in our minds, we are free to combine two operations which ordinarily would be done separately — that is, to position the model to establish the exact parting line at the same time as we position it for making the clay build-up. This can be done whenever the path of the parting line is obvious. As we saw in Chapter 6, we usually find the parting line as a separate positioning procedure before positioning the model for the clay build-up. In our example here, however, the parting line is clearly horizontal to the work surface while the model's base is perpendicular to it, and the direction of withdrawal is vertical. We can now proceed as follows.

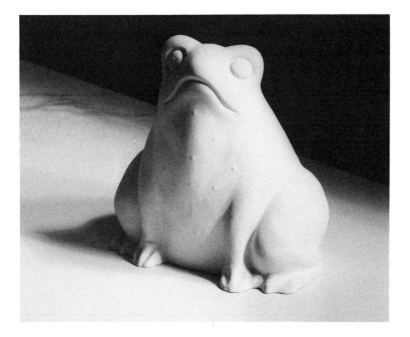

Fig. 140. Evaluate the model and estimate the parting line.

Fig. 141. Place the soaped model on a board and soft clay cushions with its estimated parting line horizontal to a large, level work surface and with its thinner section facing downward. Using a board will aid in moving the model about later as we build up the clay.

Fig. 142. Position the model so that the plane of its base is vertical to the work surface. The model may be shifted laterally around its axis to clear any undercut areas that we have made note of in the evaluation of the piece. Draw a vertical line on the base of the model at its midpoint; this is simply a visual alignment mark that is made as a precaution in case the model should be moved; the vertical line would serve to relocate the model in its exact position. Consider whether the final product requires that the spare be located in the base.

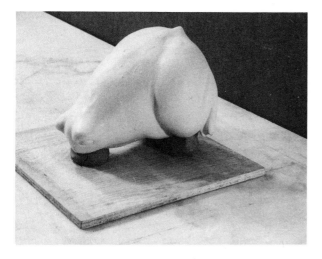

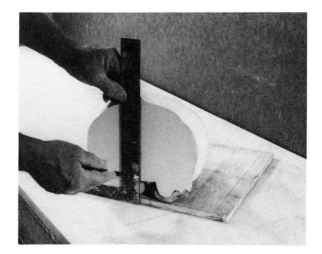

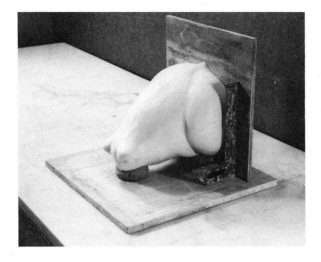

Fig. 143. When the base is to be used for positioning the spare, or if the entire surface of the base is to be used as the pouring hole, the base can be blocked off now by placing a second board firmly against it and at a 90° angle to the first board. Use clay to hold this second board in its vertical position.

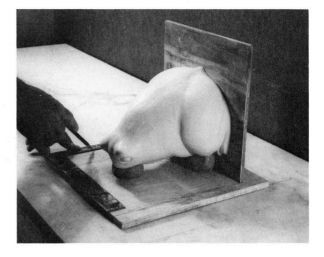

Fig. 144. At a distance of 2 inches from the model's greatest dimensions on its three exposed sides, draw three lines on the bottom board to form a rectangle completed by the vertical board at the model's base. These lines will act as a guide in making a clay build-up.

Fig. 145. Rub indelible pencil on the edge of a square along one of its arms, and move the square around the model with this edge, held vertically, touching the model. The line of pencil marks on the high spots determines the parting line.

Fig. 146. Draw a pencil line following the center of the trace left by the square. Recheck the section above the line for vertical draft and avoidance of undercuts.

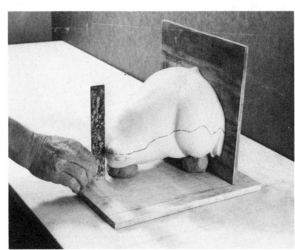

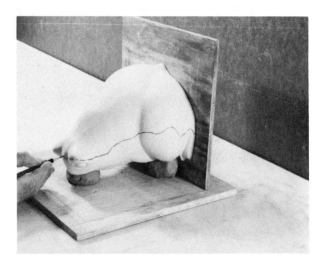

MAKING THE CLAY BUILD-UP

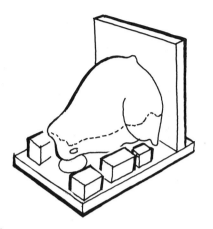

Fig. 147. On the horizontal board within the drawn rectangle, place scrap blocks of plaster to help fill up the spaces to the parting line.

Fig. 148. Begin to build up soft clay over the filler blocks, following the parting line.

Fig. 149. Use suitable tools to form the clay as it follows the parting line.

Fig. 150. Trim off excess clay on each side of the model to form vertical walls. This completes the clay build-up.

MAKING THE FIRST SECTION OF THE MODEL MOLD

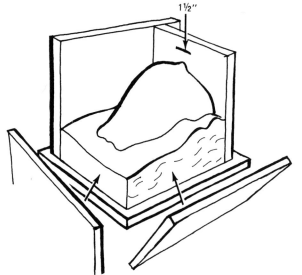

1½″

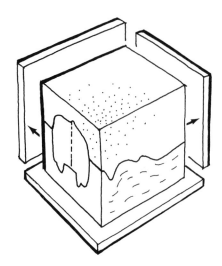

Fig. 151. Resoap the exposed portion of the model thoroughly. Place soaped boards against the walls of the clay build-up; seam and clamp them firmly. Make a casting mark 1½ inches above the high point of the model. Pour plaster into the boarded form. Tap the sides to eliminate air bubbles. Screed the top surface.

Fig. 152. When the plaster has set, remove the clamps and vertical boards, including the vertical board set against the model's base. (Drawing shows the mold turned so the model's base now faces the viewer.)

Fig. 153. Invert the remaining unit to rest cast section down on the marble. Remove the horizontal board, all clay and the filler blocks. Leave the model in the mold.

Fig. 154. Cut keys in the plaster mold section. Remove any small irregularities or feathered edges of plaster that might have occurred during the casting procedure. Soap all surfaces thoroughly, the sides of the mold as well as the top. This is the first half of the model mold.

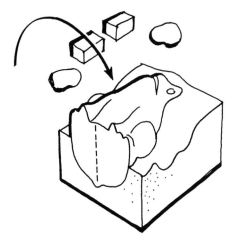

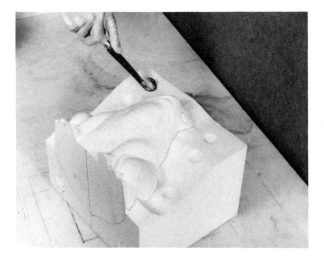

MAKING THE SECOND SECTION OF THE MODEL MOLD

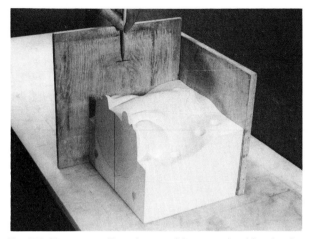

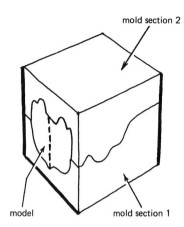

Fig. 155. Place soaped boards around the soaped mold and make a casting mark 1½ inches above the highest point of the exposed model. (Resoap the exposed portion if necessary.) Clay and clamp the boards. Mix plaster and pour to the mark. Tap the sides to eliminate air bubbles; screed.

Fig. 156. When the plaster has set, remove all clamps and boards. This completes the second section of the mold.

MAKING THE THIRD SECTION OF THE MODEL MOLD WITH A SPARE

Fig. 157. With the model still inside, rotate the two mold sections together as a unit so that the model's base is up. Cut keys in this surface of the mold. Soap the newly exposed mold surface, the keys and the model's base. Select a proper size spare. Whenever you plan to make a block, you must use a plaster spare. (To turn a plaster spare on the wheel, see page 100.)

Fig. 158. Soap the spare and place it in position on the model. Use a weight to hold it down and prevent it from floating in the liquid plaster. Place soaped boards around the unit; seam and clamp them in position.

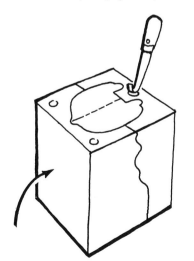

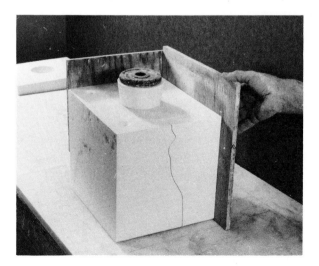

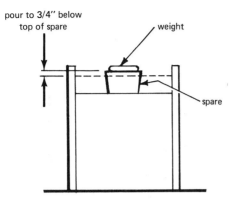

Fig. 159. Cross section shows the desired height of the third section is ¾ of an inch below the top of the spare. Mix plaster and pour to this height. Tap the sides; screed.

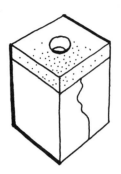

Fig. 160. When the plaster has set, remove all clamps, boards, and the spare. This completes the three-piece mold.

MAKING A BUILD-UP FOR THE BLOCKS

Fig. 161. Remove the third mold section. Rotate the rest of the mold so that the tallest or thickest section is on the bottom, resting on the marble. Soap the mold. Make a casting mark ¼ of an inch above the highest point of the mold's seam.

Fig. 162. Around the mold draw a rectangular outline on the marble at a distance of 1½ inches from all four sides. Place soaped boards around this line; seam and clamp them. Mix plaster and pour to the casting mark. Tap the sides of the boarded form.

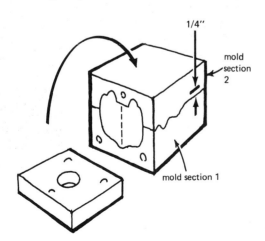

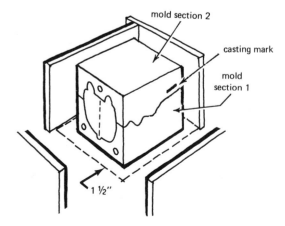

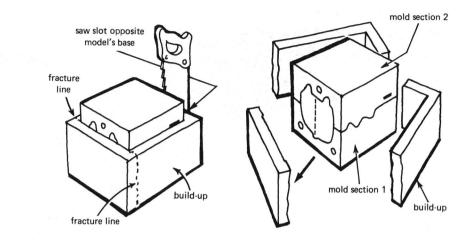

Fig. 163. When the plaster has set, remove the clamps and boards. This newly poured plaster piece is called a build-up.

Fig. 164. At a point opposite the bottom surface of the model, saw a slot in the build-up to within ¼ of an inch of the mold. Fracture the build-up by leaving the saw wedged in place and rapping the saw blade sharply on its side. The build-up will break into three sections — along the line of the slot and at the points indicated by the two dashed lines.

Fig. 165. Soap all three of the new build-up pieces and set them aside. Lift off the top half of the mold and remove the model.

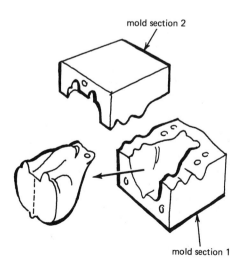

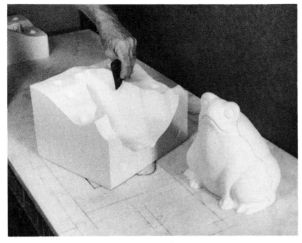

Fig. 166. Clean up the mold halves, using a scraper to eliminate troublesome areas (areas that may have been binding). Soap the inside and top surfaces of each mold section.

Fig. 167. Arrange the three soaped build-up pieces around the tallest section of the mold. Place soaped boards around the build-up, making a casting mark 2 inches above the top of the build-up. This is the desired thickness for a block. Mix *Ultracal 30* and pour to mark within the boarded form. Tap the sides of the form.

Fig. 168. When the Ultracal has set, remove clamps and boards.

Fig. 169. Invert the build-up pieces, the mold section and the block as a unit, bringing the block to rest on the marble. Remove the build-up pieces and place them to one side as they will be used again. Leave the mold section on the block. This completes the first block on the thickest section of the mold.

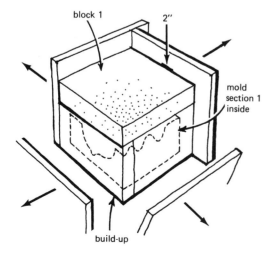

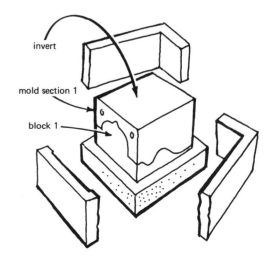

MAKING THE SECOND BLOCK

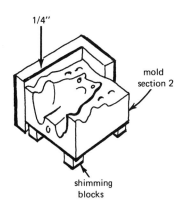

1/4"

mold
section 2

shimming
blocks

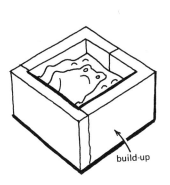

build-up

2"

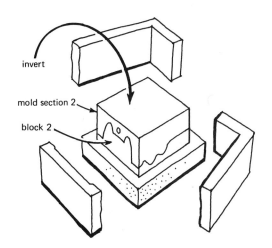

Fig. 170. Place the second (thinner) mold half face up on the marble. Place one soaped L-section of the build-up around one corner of the mold. Using shims (wooden, plaster or metal wedges) and blocks, raise the mold section so that its highest point is ¼ of an inch from the top of the build-up.

Fig. 171. Place the remaining two soaped sections of the build-up around the raised mold section.

Fig. 172. Around the build-up, place soaped boards and clamp. Make a casting mark 2 inches above the build-up. Mix *Ultracal 30* and pour to mark. Tap the sides of the boarded form.

Fig. 173. When the Ultracal has set, remove clamps and boards.

Fig. 174. Invert as a unit the build-up, the mold section and the newly poured block, so that the block rests on the marble. Leave the mold on the block. This completes the block on the second section of the mold.

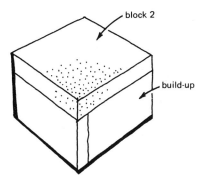

block 2

build-up

invert

mold section 2

block 2

MAKING THE THIRD BLOCK

Fig. 175. Place the third section of the model mold on the marble and clean it up, scraping any irregularities from its top surface. Soap the section thoroughly.

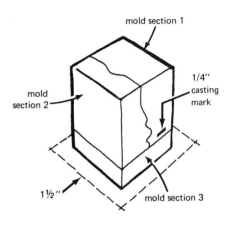

Fig. 176. Remove mold sections one and two from their blocks and reassemble them on top of this end mold section, which is bottom-surface down on the marble. Draw a rectangle on the marble at a distance of 1½ inches from the mold around all four sides. Make a casting mark ¼ of an inch above the seam of section three. Place soaped boards around the rectangle; seam and clamp them to form the casting area for a new build-up. Mix plaster and pour to the ¼-inch mark.

Fig. 177. When the plaster has set, remove clamps and boards. This is the build-up for making a block and case for the end section of the mold.

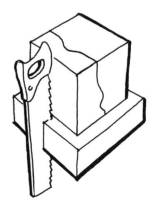

Fig. 178. Midway on the shorter side of the build-up, saw a slot to within ¼ of an inch of the mold.

74

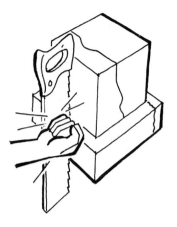

Fig. 179. Fracture the build-up into three pieces by rapping the saw blade sharply on its side with the saw still in place in the slot.

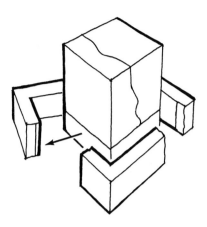

Fig. 180. Open the build-up, releasing the mold. Soap the build-up pieces.

Fig. 181. Remove the first two sections of the mold, leaving only the end section bottom-surface down on the marble. Cut small keys in the bottom surface of the plaster spare.

Fig. 182. Place the spare keyed-surface-up on the marble, cushioning it with clay. Gently place the end mold section over the spare so the spare fits into the pouring hole in the mold. As the spare is taller than the mold, raise the mold with shimming blocks so its top surface is flush with the keyed surface of the spare. Reassemble the build-up around the raised mold section, using more blocks to raise the build-up ¼ of an inch above the top surface of the mold section. Level the assembled mold and build-up.

mold section 3

cut keys

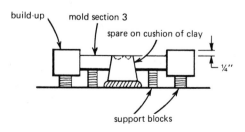

build-up mold section 3

spare on cushion of clay

¼"

support blocks

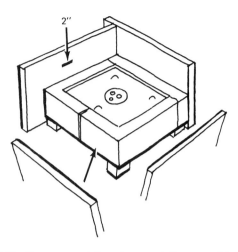

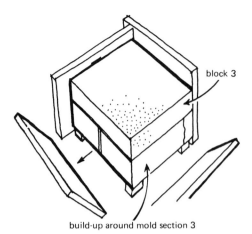

Fig. 183. Place soaped boards around the assembled mold section and build-up; seam and clamp them. Make a casting mark 2 inches above the build-up. Mix *Ultracal 30* and pour to the mark.

Fig. 184. When Ultracal has set, remove the clamps and boards.

Fig. 185. Invert the block, build-up and mold as a unit. Remove the build-up and the shim blocks. Leave the mold and spare on the newly poured block. This block is actually a flat surface with small bumps on it corresponding to the keys in the spare. To make a duplicate mold of this section, the spare will be placed on the block, so the keyed surface and the bumps fit together, and it will be weighted down before the plaster is poured.

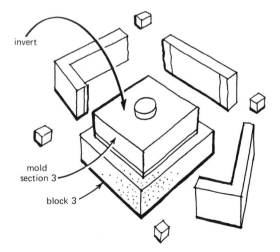

76

MAKING CASES ON THE FIRST TWO BLOCKS

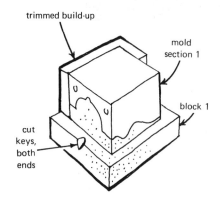

Fig. 186. As is the case many times in mold-making, the plaster build-ups can be used again in subsequent steps of the procedure. Here, the build-up that was made for the blocks now is used in starting the case construction. Select either of the two large "L" sections of the build-up made for sections one and two (page 71). With suitable tools, smooth the fractured edges.

Fig. 187. Fit the first block and its corresponding mold section together and place the unit on the marble surface with the bottom surface of the block on the marble. Cut two keys in the block as indicated. Soap the entire setup thoroughly. Soap the trimmed "L" section and place it on the block as shown.

Fig. 188. Place two soaped boards around the block and one on the block as shown, to seal off the first casting area, which will be an "L" shape. Seal and clamp the boarded form. Mix plaster and fill this area, pouring until the plaster is ⅛ of an inch higher than the top surface of the mold section. While the plaster is setting, screed this overflow flush with the top of the mold. When the plaster has set, make final passes to impart smoothness; then remove clamps and boards. Remove the build-up (X).

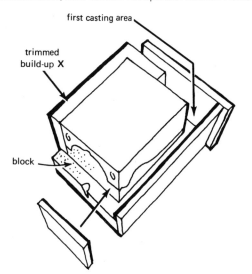

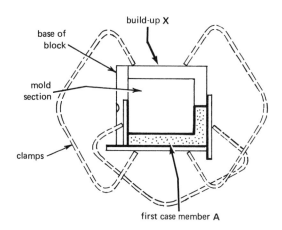

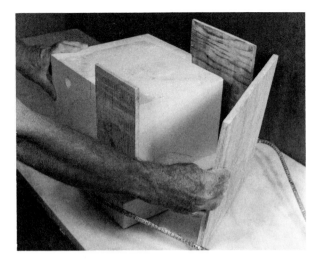

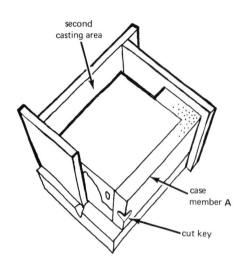

Fig. 189. Photograph shows first L-shaped casting area being boarded.

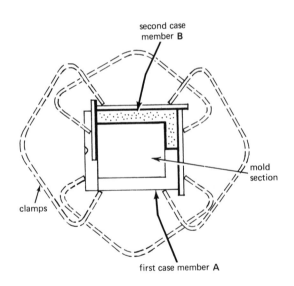

Fig. 190. The previous step has produced the first case member (A). Remove it from the block and carve a key in one vertical edge. Soap case member A and replace it in its previous position on the block. With case member A in place, board and clamp a second L-shaped area to be cast. Mix plaster and pour to a height of 1/8 of an inch above the mold and screed flush as before. This produces the second case member.

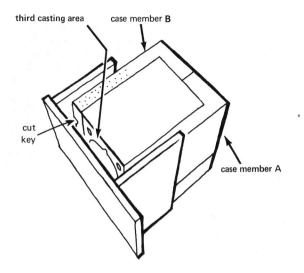

third casting area — case member **B**

cut key

case member A

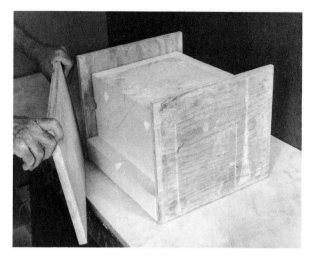

Fig. 192. Photograph shows boards being placed to cast third case member. Note that the keys in the bottom of the mold section will form positive keys on the case member.

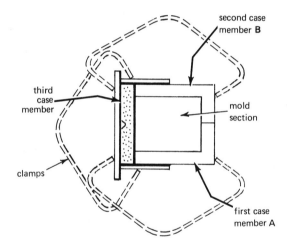

second case member **B**

third case member

mold section

clamps

first case member A

Fig. 191. Cut a key in the new case member, soap it and replace it on the block, along with case member A. With both case members A and B in position, place soaped boards around them and the end section of the block. This will be the casting area of the third case member. Seam and clamp the boards.

Mix *Ultracal 30* and cast this end section, again pouring to a height of ⅛ of an inch above the mold and screeding the Ultracal flush with the top of the mold. When this has set, remove clamps and boards. (Ultracal is used here instead of plaster because this section fits flush against the base configuration of the model and will form an inner surface of the production mold.)

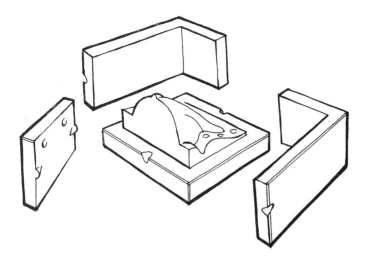

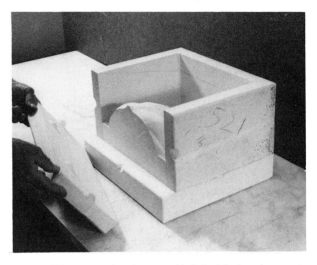

Fig. 193. Lift off the case members and remove the mold section from the block. The block and case for the first section of the mold is complete. The drawing shows that the outside edges of the block and the case members have been chamfered to prevent chipping. Never bevel any inside edges.

Fig. 194. When soaped and reassembled, the block and case are ready to be boarded and clamped to cast a section of the production mold. To obtain cases for the second block, fit that block together with its corresponding mold section and repeat the boarding up procedures used in Figs. 188 to 192.

THE THIRD CASE SET

Fig. 195. Place the third block on the marble; its corresponding mold section, including the spare, should still be in place on the block. Soap the mold and block. Place boards to seal off an L-shaped area for casting as shown. Clamp boards and pour plaster to ⅛ of an inch above the mold. Screed flush. When plaster has set, remove clamps and boards. This produces the first of two case members to be cast. Remove it from the block and soap it.

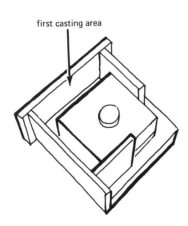

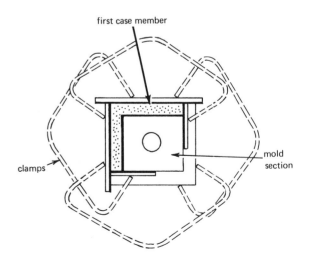

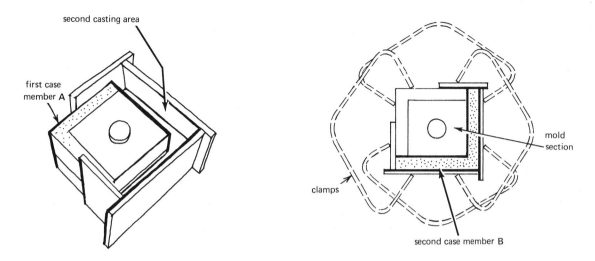

Fig. 196. Replace the first case member on the block; place soaped boards to seal off the second casting area as shown. Clamp the boards. Mix plaster and pour to height of 1/8 of an inch above top of mold section and screed flush. When plaster has set, remove the boards and clamps. This produces the second, longer-armed case member. (As the two case members are self-seating, no keys are necessary.)

Fig. 197. Remove the model mold. Trim the outer edges of the block and case. Reassemble the case members and the spare on the block. When soaped, the unit is ready to cast the third section of the production mold.

Fig. 198. The finished product, a ceramic hurricane lamp, was made from molds produced by these blocks and cases. Mouth and holes in eyes and body surface were cut into cast model at the greenware stage.

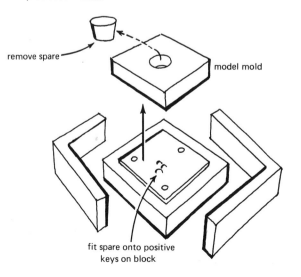

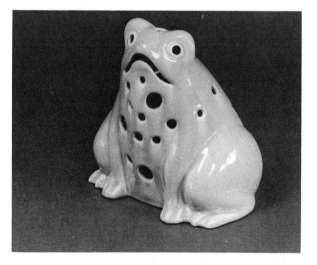

8. Multi-Piece Molds: Problems and Solutions

When we have examined a given model and reached the conclusion that a one-piece or a two-piece mold cannot be employed to duplicate the piece, we must look to the multi-piece mold for a solution. We have seen that, in analyzing a model to determine its parting lines, surface features play a major role in deciding the direction of mold-section withdrawal, which, in turn, dictates the number of mold sections required.

We usually attempt to withdraw sections of a mold at a 90° angle to the general plane of the model surface (Fig. 199); however, wherever there are indentations — such as those at the legs of the model rhinoceros (page 35), or in the claws of the bird (page 34)—the indentations rather than the general plane of the surface serve to determine the direction of withdrawal. This is because the shape of a groove or indentation automatically limits the usable angle of withdrawal; the firm piece of plaster that is to withdraw from between the walls of the groove cannot exceed the angle of the walls themselves (Fig. 200). The deeper and more severe the angle of the groove or indentation, the less of an option we have in withdrawing from it, while, conversely, the more shallow and gentle the angle of the groove, the greater the latitude we have in withdrawal angle (Fig. 201).

A good example of how the angle of indentation de-termines the number of mold sections necessary is seen in the fluted, rounded form (Fig. 202), which contains many grooves, like a gear, and which can serve to help plan a mold for any rounded object that has raised or depressed decoration on any portion of its surface. In this case, the angle of the fluting is not severe, allowing us to keep the number of mold sections to four (Fig. 203). Sharper angles of fluting would have meant fewer flutes could be encompassed with one section, and consequently, more sections would have been required.

CROSS-SECTION DRAWINGS

The view in Fig. 203 is a cross-section of the fluted form; it shows plainly what is happening inside the mold. Cross-section drawings serve us well in planning our future moves. To understand this type of drawing it is only necessary to remember that a cross-section is nothing more than a slice of an object — it is what you would see if you cut through a model at a given point with a plane that is usually at right angles to the axis of the model (Fig. 204). It is a true picture in that the shapes of parts, the spaces between members, and the relative positions of portions of the model at that point can be seen clearly.

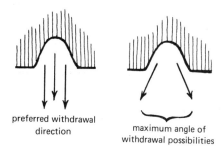

Fig. 199. Withdrawal of the mold section at a 90° angle to the general plane of the model's surface is preferred but not always possible.

Fig. 200. Indentations in the model's surface dictate withdrawal possibilities.

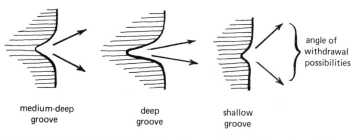

medium-deep groove

deep groove

shallow groove

Fig. 201. The shallower the indentation, the greater the withdrawal possibilities.

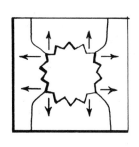

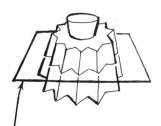

Fig. 202. The fluted surface of the model determines the number of mold sections necessary.

Fig. 203. Cross-section shows a four-piece mold can encompass all the indentations and still be withdrawn.

Fig. 204. Cross-section shows what the model looks like if you slice through it and look straight on at the exposed end.

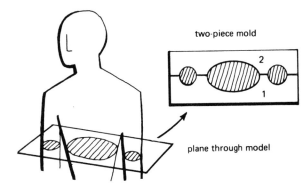

two-piece mold

plane through model

Fig. 205. Cross-section view is helpful in planning the mold because it shows the relationships between portions of the model.

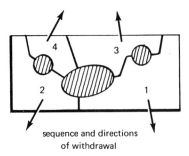

sequence and directions of withdrawal

Fig. 206. Cross-section of the same model with arms and torso shifted shows a four-piece mold is now necessary to clear all surfaces.

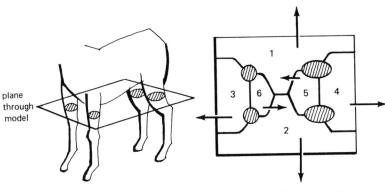

plane through model

sequence and directions of withdrawal

Fig. 207. Cross-section of the legs of a horse shows a six-piece mold is necessary for the legs alone.

In drawing a rough cross-section of your own model, try to visualize what it would look like if you had cut through the model and were looking straight on at the exposed end. Cross-sections help to show angles of withdrawal because the clearances a section must make in being moved away from the model are revealed.

An example of this is seen in Fig. 205, where we show the space relationships of the arms and torso of a figure. If we shift the relative positions of the arms and the angle of the ellipse of the torso (Fig. 206), an entirely new set of clearances comes into play. In the first drawing (Fig. 205), the oval shape of the torso lies centered between the two cylindrical arms, and there is ample clearance to successfully withdraw a two-piece mold without undercutting. (Since a standing figure is usually laid on its side to be worked upon, the angles of withdrawal in the cross-section show a pull to the top and bottom.)

When the shift takes place and the arms are moved slightly as in Fig. 206, the relationships of the curves of the torso to the curves of the arms are such that one mold section cannot be withdrawn from around them; the mold must be broken into sections, each of which is withdrawn as shown by the arrows. To satisfy the new situation, therefore, instead of a two-piece mold, we have a four-piece mold. Had we been designing the mold, this is where our rough cross-section drawing would have revealed the difference.

In like manner, if we take a slice through the legs of a model animal with four legs (Fig. 207), we can see that to give adequate clearance around the curve of each leg, the number of pieces jumps to six, a not uncommon number for nearly any four-legged figure mold. In this cross-section we can clearly plan the angles of section withdrawal, numbering each as they withdraw. Some models of animals eventually end up requiring thirteen or fourteen sections by the time the entire figure is completed.

84

PARTS REMOVED

Rather than cope with overly complicated molds, it is only fair to say that some mold-makers avoid them by simply removing the complicating member from the body of the original model, assuming that the final piece is to be cast in ceramic slip. This is especially true for small members such as ears, fins, horns, etc., where the joint will be unobtrusive in the final form. These removed members are treated as separate models, each with its own mold sections; they are cast separately and rejoined to the parent body in the greenware stage, with the joint sponged to conceal any small irregularity.

This is not to say that all difficult situations can be treated in this way, nor that models need be changed to suit the requirements of the mold; it is to say that these measures are not uncommon, that we may use them if the case arises, and that as sculptors, we can sometimes be guided in our choices of form configuration if we can anticipate how the mold must break to accommodate our design.

INTERSECTIONS

Regardless of whether we remove parts or not, the cross-section drawing gives us a view of the model through a given point; it is an ideal opportunity to draw in the lines of the mold sections, especially since the intersections formed where mold line meets model surface should occur as close to 90° as possible (Fig. 208). This type of intersection prevents the easily made error of angling the plaster edge, which is then very prone to breakage in being handled. Further examples of correctly drawn intersections can be seen in Figs. 206 and 207.

Fig. 208. Mold seams should meet model's surface at a 90° angle.

Fig. 209. The cross-section of a model shows section A is thinner than section B and can be blocked off with clay fastest. This tells us the casting sequence.

Fig. 210. Model is inverted; clay build-up is made to block off section A, and section B is cast first.

CASTING SEQUENCE

Again, using the cross-section drawing as a guide, we can not only establish the number and location of the sections required, but we can, at the same time, plan the sequence and position for casting the various sections of the mold. A simple shape, such as in Fig. 209, can be divided for a two-piece mold with section A being thinner than section B. The determining factor as to which section is cast first, and this holds true in nearly every casting situation, is simply to cast that section which requires the least amount of time and effort to make the clay build-up. In this case, since A is thinner than B, it is less work to cover up A with clay. Consequently, we plan to invert the model so that A is down and the clay can be built up to cover it. The first section to be cast, then, is B, and the casting sequence is cast B first, then A (Fig. 210).

85

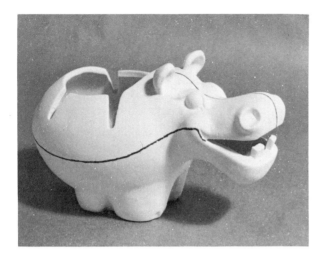

Fig. 211. Parting lines drawn on model of a hippopotamus.

A very similar model is that of the hippopotamus (Fig. 211). Here we find the parting line much as we would for a two-piece mold — using the square and tracing it horizontally around the body, dividing the mold into a top and a bottom. We plan to remove the ears and cast them separately. Even so, in order to clear the protruding eyes and nostrils, it is necessary to divide the top section into a left and a right withdrawal. Technically, then, we have a three-piece mold as seen in the cross-section drawing (Fig. 212). As in Fig. 210, we plan to build up the thinnest section, which means inverting the model and then building the clay bed up to the horizontal parting line. This means the first section to be cast in plaster will be over the leg area of the bottom (Fig. 213).

Next, we plan the second cast to be one of the two remaining sections; therefore, we plan to leave clay built up to the second parting line (Fig. 214). We turn the first section cast and the model 90° so that the casting cavity will be in position to receive the pour when the retaining wall is

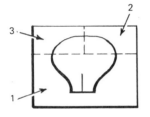

Fig. 212. Cross-section of mold planned for hippopotamus shows casting sequence.

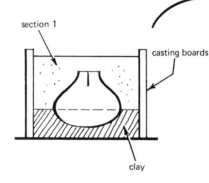

Fig. 213. Clay build-up covers thinnest section, and section one is cast.

Fig. 214. Unit is turned 90° and clay is removed from section two.

Fig. 215. Unit is boarded and section two is cast.

Fig. 216. Unit is turned 180°, remaining clay is removed, and section three is cast.

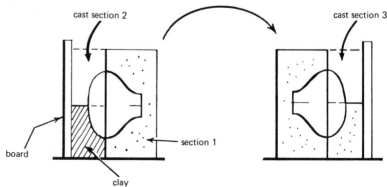

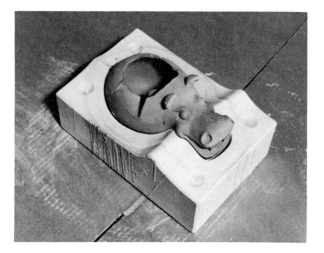

Fig. 217. Slip-cast clay piece is shown in mold section one. Ears were cast separately and attached to cast piece.

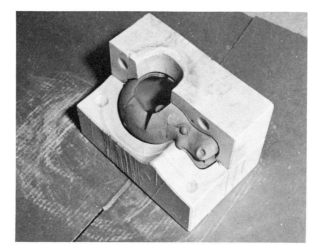

Fig. 218. Mold section three over cast piece.

in its proper position (Fig. 215). The whole unit will then be inverted, with casts one and two in position over the model, and the blocking-off clay will be removed, leaving just the last section of the model to be cast (Fig. 216).

Thus the casting sequence has been thought out in advance and guides our actions in actual application. The mold that resulted from this plan is shown in Figs. 217, 218 and 219. The cast clay piece has been reinserted in the mold to show the relationships more clearly. This mold, as shown, also includes the pouring hole, which was formed by filling the hollow model with clay and extending the clay up to the casting mark. The mouth was also filled with clay, flush with the front surfaces of the teeth, so the top and side surfaces of the teeth and the surrounding open space in the mouth must be cut out by hand after the piece is cast and fairly firm.

By now it should be evident that molds are actually designs — that they must be thought through not only simply to form the piece, but to withdraw properly, to be shaped properly, and to have a definite order in their making and in their functioning. There remains another property of a good mold which has not yet been mentioned and that is the locking principle.

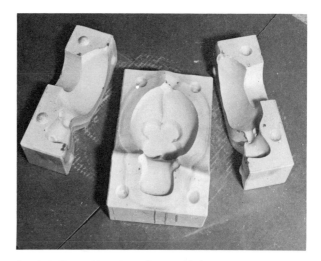

Fig. 219. The mold sections disassembled.

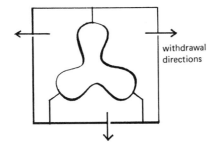

Fig. 220. Cross-section of a three-piece mold showing locking principle. The two large sections enclose the third smaller section.

THE LOCKING PRINCIPLE.

We have seen that two-piece molds assemble in a rather straightforward fashion along a single seam line; keyed sections are firmly held together with clamps or rubber loops. Multi-piece molds, however, call for the application of the locking principle; this principle stipulates that all the sections of a multi-piece mold be so made that they seat themselves one into another, with the sections usually diminishing in size, ending in a complete mold that is a self-contained unit. An example of this can be seen in Fig. 220, where two large sections enclose a third smaller one, locking it in place. Keys are always used, of course, for critical alignment on all molds. In the locking principle, the outside sections of the mold are usually the largest, each additional section being smaller and being held in a relatively immovable position by the larger pieces. Pressure applied to the outside by clamps or rubber loops does not cause the mold to fly apart as would be the case if all sections were of equal size. Other examples can be seen in Figs. 206 and 207, where the two outside sections contain the smaller inside ones.

A three-piece mold using the locking principle was made to reproduce the piece shown in Fig. 221. The parting line shows the model divided into two large halves with the third small section forming the area inside the two antennae of the snail (Fig. 222). (In all of these examples where hollow models are shown, it should be noted that the models are filled with clay before being worked upon.) Fig. 223 shows the third mold section in position on a larger section, while Fig. 224 shows both it and the cast snail removed, exposing the casting hole in the other section of the mold. Figs. 225 and 226 show the cavity for the third section and how the first section and second section secure the third one in position.

Referring to Fig. 227, we can now see how we choose the first section to be cast. It is one of the two large, locking outside sections, and further, it is the section that requires the least build-up. The second section to be cast is the other large, locking section. The unit is then inverted and the medium-sized inner section is cast. Finally the clay is removed from the smallest section and the last cast is made.

Fig. 221. Model of a snail with parting lines drawn for a three-piece mold.

Fig. 222. Top view of model shows it divided into two large halves which enclose a third, small section forming the area between the antennae.

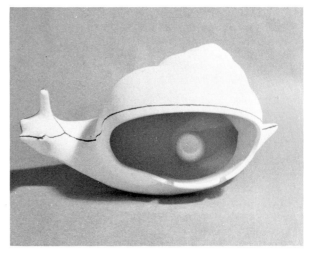

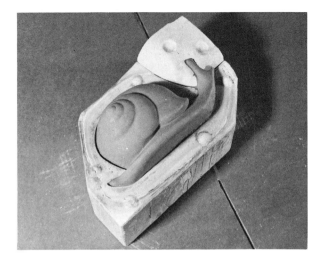

Fig. 223. Slip-cast piece placed in half the mold with third mold section in position.

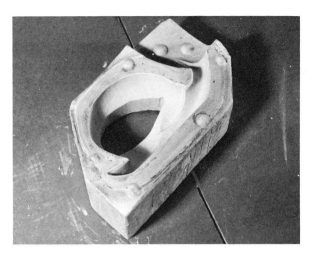

Fig. 224. Cast piece and third mold section have been removed, exposing casting hole in large section of the mold.

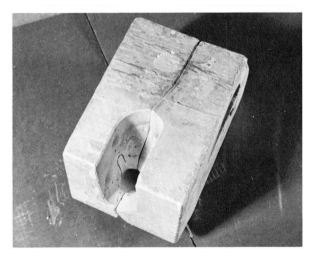

Fig. 225. Two large sections assembled show the cavity for the third mold section.

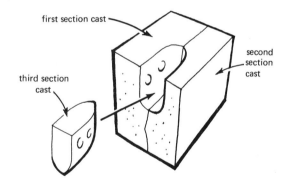

Fig. 226. Diagram shows how large sections hold small section in place.

Fig. 227. Casting sequence for mold in Fig. 206 shows large locking sections are cast first, and smallest section is cast last.

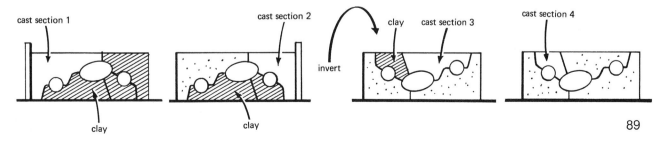

FURTHER VARIATIONS

Not every mold requires such an obvious use of the locking principle, although leverage does play its part in holding even simple molds together. Figs. 228 and 229 show a model that calls for a three-piece mold that maintains its unity by using a T-shaped configuration — two halves capped by an opposing third section.

The seam line runs down the middle of the model and then shifts to the upper edge of the forked tail section. Fig. 230 shows the cast piece in position with one of the mold halves removed, while Fig. 231 shows the rear section removed.

The mold for this model was made in a sequence which started with a build-up as shown in Fig. 232. The first cast

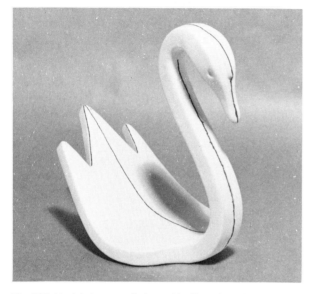

Fig. 228. Model of swan calls for mold with two large halves.

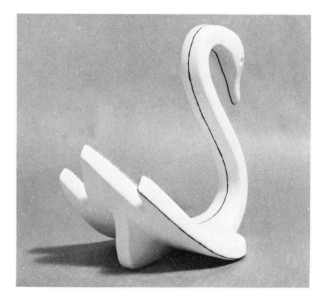

Fig. 229. Bottom of swan is formed by third mold section capping the two halves.

Fig. 230. Slip-cast piece with one of the mold halves removed.

Fig. 231. Slip-cast piece with the rear mold section removed.

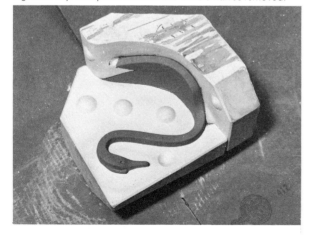

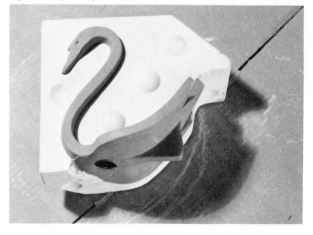

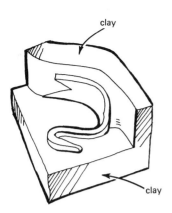

Fig. 232. Model with clay build-up over second and third mold sections.

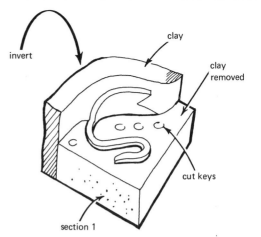

Fig. 233. Model with first mold section cast and clay removed for casting second section.

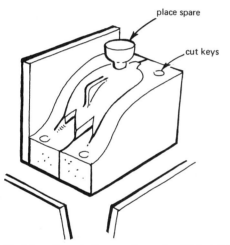

Fig. 234. Model positioned with spare for casting third section.

was made, the unit was then inverted, and the clay of one section was removed. The clay still covering the bottom section was smoothed to proper shape, and keys were cut in the first plaster section (Fig. 233). A second half-section was then cast. Finally, the clay covering the bottom section was removed and the first and second sections were clamped together with the model in place. A small turning was placed on the bottom of the model to make the spare opening (Fig. 234). Boards were placed around and the third section was cast.

APPLYING THE PRINCIPLES

Given a model of a whale as shown in Fig. 235, we examine it carefully, and our analysis tells us that the piece divides into a left and a right withdrawal, with a third section forming the whale's back and the front surface of the tail — this third section withdrawing vertically. Consequently, we draw the parting lines on the model (Fig. 236).

Fig. 235. Model of a whale can be divided into three sections.

Fig. 236. Top view of whale shows third section will form the whale's back and the front surface of its tail.

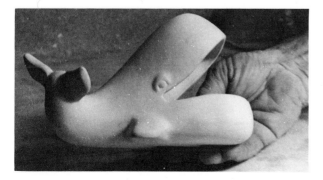

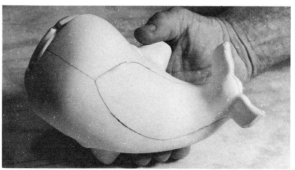

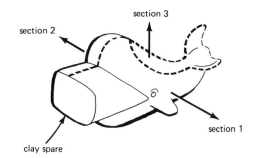

Fig. 237. Clay spare is to be placed in hollow of whale's mouth.

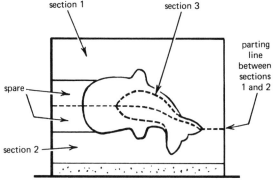

cross-section with base facing viewer

Fig. 238. Cross-section of the model with the base facing the viewer. Note parting line between section one, which forms only one edge of the tail, and section two, which forms the rear surface and the other edges of the tail.

Fig. 239. Soaped model on clay cushion with base vertical to base board and the parting line between sections one and two generally horizontal.

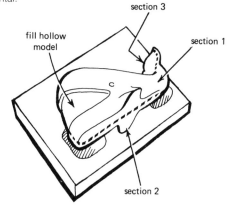

We know that the mouth is to be cut out by hand in the finished clay piece, so this is a natural location for the spare. This means that a spare must be made of clay to fit in the mouth area (Fig. 237).

We draw our rough cross-section of the model and mold in position on the work surface so that we can plan the casting sequence (Fig. 238). By positioning the model on its side, with the base of the model vertical, we can cast the mold in three sections. To facilitate moving the model about on the work surface, we use a wooden board or cast a rectangular slab of plaster 1-inch thick and 1½ to 2 inches larger all around than the model (Fig. 239). Calling upon our experience in positioning a model for casting (Chapter 6), we place the soaped model on cushions of clay, with the base vertical to the work surface. We can shift the model by raising or lowering the head or the tail, but we must keep the base vertical.

Around the plaster slab, we clamp butted boards covered with a layer of wax paper, to form a box (Fig. 240). Into this box we can start to wedge soft clay and build up the clay to the approximate height of the parting line. With the clay roughed in, we remove the boards and clamps and peel off the wax paper (which served to keep the clay from sticking to the boards). We then continue to apply clay more carefully as we reach the parting line; the clay surface should be smoothed to make as gentle a curve as

Fig. 240. Boards placed around base board help in making the clay build-up.

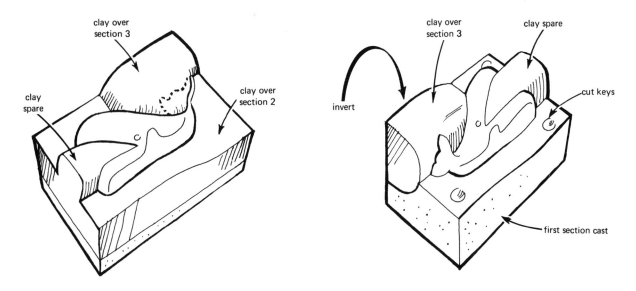

Fig. 241. Clay build-up covers section two and section three; the vertical walls are trimmed flush with the edges of the base board. Boards are placed around and section one is cast.

Fig. 242. Unit is inverted so section one just cast is on the work surface. Clay is removed from section two and keys are cut in section one. Unit is boarded and section two is cast.

possible, continuing around the model. The excess which accumulates around the edge is trimmed flush with the slab, using a long-bladed knife.

The small section that is to be cast last is also covered over with clay and its contour smoothed, so that both sections two and three are now blocked off (Fig. 241). Boards are placed around the clayed model and the first section is cast.

The unit is then inverted and the clay is removed from section two. The clay over section three, as well as the clay for the reverse side of the spare, is now formed and smoothed (Fig. 242). Keys are cut in the first section, which is then soaped. Boards are put around the form and section two is cast. The two large locking halves are now complete.

One of these halves is now removed and the clay over section three is removed (Fig. 243). Keys are cut in

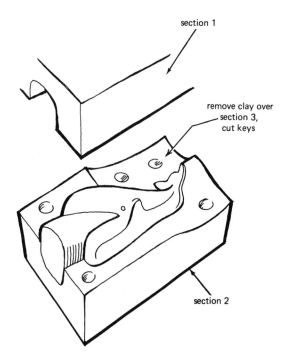

Fig. 243. The mold sections are separated and clay is removed from section three. Keys are cut for section three in sections one and two.

93

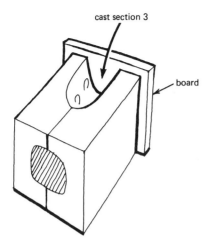

cast section 3

board

sections one and two in this area to be occupied by section three. This area is then soaped and the two halves are reassembled and clamped together with the opening of section three in the up position to receive the pour. The retaining board is placed in position and section three is cast (Fig. 244). The mold is then opened and the clay spare is removed from the model and mold. Any rough areas are cleaned up and the mold is complete (Fig. 245). The glazed and fired ceramic piece cast from this mold is shown in Fig. 246.

Fig. 244. Sections one and two are reassembled so the cavity for section three is in an up position. Retaining board is positioned and section three is cast.

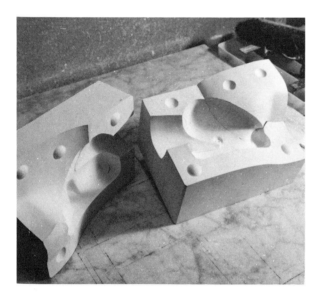

Fig. 245. The completed mold; section three is in place over section two.

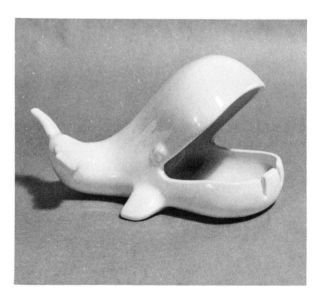

Fig. 246. The glazed and fired ceramic piece cast from the mold.

9. Extruding Plaster with the Jack

The craftsman encounters models made from many different materials, clay, wood, and plastilene being the most prevalent. These all have a recognized place in the spectrum of model materials, each satisfying a specific need. Plaster, however, provides the best model properties of all because of its workable versatility. It is firm and can be cut like wood; it can be given a rough finish or it can be glass-smooth; it can be used in a fluid or a solid form; it can be added to and it can be carved. Often, even when an original model is made in a malleable material like clay, the craftsman will cast a waste mold of the clay and then cast a plaster model on which to work. Then, after the plaster model has been finished as desired, a model mold is made from it, not from the clay original.

At other times, a model is made directly in plaster — often by carving and cutting from a solid block. Profiles can be drawn on a block of plaster and band-sawed to a rough shape, then hand-finished with appropriate tools.

This method is used most often for achieving asymmetrical shapes.

Other than profile carving, there are basically two ways to form plaster: (1) by extruding it with a jack, and (2) by turning it to obtain either a complete model or sections of a model that can be combined with mold-making procedures in order to obtain the final plaster model (as will be described in Chapter 11).

CONSTRUCTION OF A JACK

If one expects to do much plaster model-making, it will be necessary to have access to, or to build for himself, what is called a "jack" or sled. This is a simple piece of equipment, easily made, which is used to extrude plaster. One arm slides along the edge of the work surface while the other arm holds a sheet-metal template in position; the template

is pulled over wet plaster and leaves in its wake a ribbon of formed plaster molding (Fig. 247). It is a method of forming lengths of plaster having a definite profile (Fig. 248).

A jack is basically three pieces of lumber: (1) a running board, (2) a template arm, and (3) a brace (Fig. 249). The running board is always held firmly against a guiding edge, which can be the edge of the work table or the edge of a guide board that has been clamped firmly to the work surface.

At a right angle to the running board is the template arm, to which any template can be fastened. The template itself is made from sheet metal, cut to the desired shape. The brace anchors the arm to the running board and maintains its rigidity while the jack is pulled through the plaster.

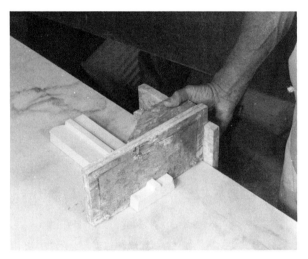

Fig. 247. Typical jack and section it has formed.

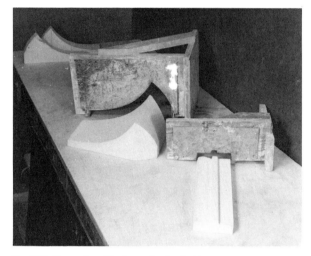

Fig. 248. Examples of jacks and extruded forms.

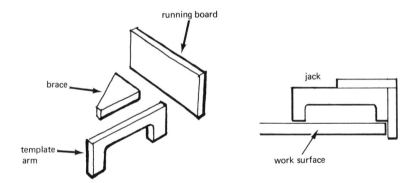

Fig. 249. Construction of a simple jack.

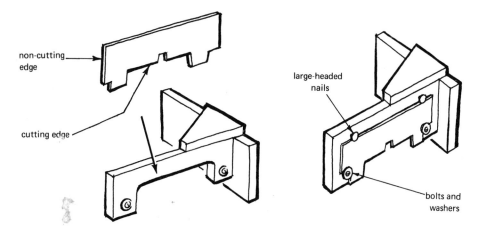

Fig. 250. Metal template notched to fit bolts of jack.

non-cutting edge

cutting edge

large-headed nails

bolts and washers

USING THE JACK

In operation, the jack is used as follows: The desired contour is cut from the sheet metal to form the template, which is then attached to the template arm (Fig. 250). Templates may be made from sheet zinc or brass, but most often they are made from galvanized sheet metal. When using galvanized metal, it is sufficient to file the cutting edge square, smooth and sharp; when using thicker stock, it is advisable to file the cutting edge at an angle, to give material clearance behind the blade face. When the design is such that the wooden template arm follows the contour of the template, the wood should also be cut away at an angle to allow material clearance. There should be at least ⅛ of an inch of template extending beyond the wood of the template arm (Fig. 251).

For fastening the template, holes can be drilled in the metal to take screws or nails, but slots or notches cut along each side, and used with pre-positioned bolts and washers screwed into the template arm, act to save time. With the slot arrangement, critical positioning of the template is easily accomplished by simply releasing the pressure on the washers and then retightening them after the template has been shifted. The top edge of the template is then secured by large-headed nails.

To prepare the plaster, draw an outline on the marble work surface of the anticipated length and width to be run. Be sure to position the outline so the edge of the table can act as a guide for the running board. Place casting boards around this rectangle, allowing an extra ¼ of an inch space on each long side (Fig. 252). Be sure to soap the boards

Fig. 251. Thick templates require angular trimming of cutting edge.

Fig. 252. Plan the required length and width to be run. Outline it on the marble in a position that allows the side of the running board to be flush against the edge of the work table when the piece is run.

97

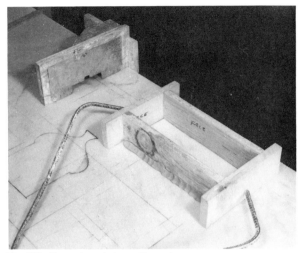

Fig. 253. Clamp boards in position; clay seams.

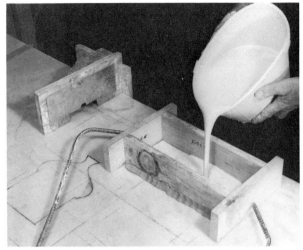

Fig. 254. Pouring the plaster.

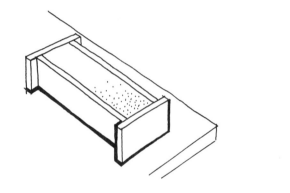

Fig. 255. Remove clay; slide boards off while plaster is still wet.

Fig. 256. Make several passes, removing a little plaster at a time. Work in one direction only.

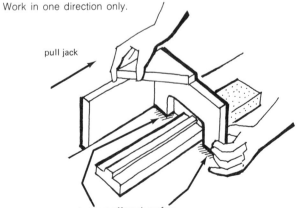

pull jack

hold up off work surface

thoroughly and to oil them as well, in order to make sure they will slide away from the plaster without ripping or tearing the edges after the strip is cast. Naturally, the size of the jack should correspond to the width of the plaster to be run. Clay the seams and clamp the boards firmly (Fig. 253). Mix the plaster and pour to the height required (Fig. 254). When the plaster is still very wet, that is, just barely able to hold its shape, remove the clay seams, *slide* the boards off the slab (Fig. 255), and quickly place the jack in position at one end of the plaster.

The jack is then pulled firmly but carefully over the plaster mass; the template cuts its profile as it moves through the material. Be sure the running board is always held firmly against the guiding edge. Do not try to take off all of the plaster on the first pass, but start the run with the jack held a little higher than its final position and make

several passes over the plaster, lowering the jack a little bit at a time (Fig. 256), until the final pass is made. Make all passes in one direction only. After each pass, quickly wipe the template clean of the scraped plaster.

When the desired profile has been reached, the operation is complete; remove the jack and clean the template. Often it is wise to clamp an anchor block at one end of the table where the plaster is to be poured to prevent any movement of the plaster when it is being extruded (Fig. 257). Also, when making several passes, it is advisable to sprinkle water on the plaster surface before making each pass; this will give a smoother ride to the cutting edge.

RUNNING A SECTION

When the text calls for "running a section," we are referring to this process of using the jack. One always "runs a section" with a definite profile having been planned for it and the profile is cut from the template metal.

ADDITIONAL USES

Not only does the jack allow us to obtain sections of plaster that have a consistent profile, it also allows us to run decorative shapes that would otherwise be impractical to even consider.

Suppose we desired a section with a texture of wavy, U-shaped troughs (Fig. 258). By cutting a wavy contour out of hardboard to use as a guide for the running arm, we can make the whole jack follow the wavy contour. By cutting the template with as many U-shaped teeth as we need to cover the area, we can run a section that combines these two features: wavelike motion and multi-trough. To achieve this, the only necessary modification to the jack is to nail into the bottom of the running board two brads as illustrated (Fig. 259). The operator then keeps the brads in contact with the wavy guide board just as he would along the length of a flat guide. Since the brads act as contact points only, they are free to follow the wavy contour of the guide.

Motion can also be added to the other axis of the jack, creating an up-and-down movement in addition to the in-and-out planar movement just described. This adds further dimension to the pattern in plaster.

In this case, two vertical guides are cut from hardboard and braced at each end (Fig. 260); this gives a good parallel support to the template.

With these three options of running sections, many textures can be obtained which would prove prohibitive by any other means.

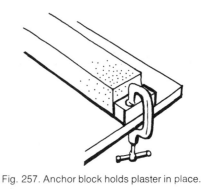

Fig. 257. Anchor block holds plaster in place.

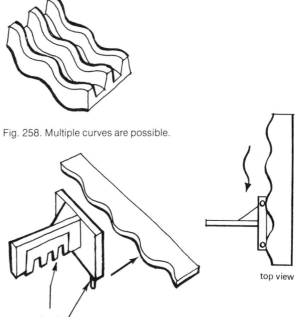

Fig. 258. Multiple curves are possible.

Fig. 259. Brads in bottom of the running board make it possible for the jack to follow a curved guide board.

top view

brads

Fig. 260. Up-and-down motion can also be cut.

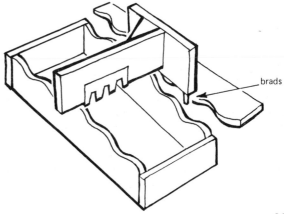

brads

10. Turning Plaster

There are several methods of turning plaster. They may be divided into those in which the plaster turns and those in which the template turns.

There are four methods of *rotating* the *plaster:* (1) plaster-wheel turning, in which the plaster is removed while in a wet state, with hand-held tools or templates; (2) turntable turning, in which the wet plaster is shaped by a template which is fixed to a bridge; (3) box turning, in which plaster is turned on a rod in a box and the template is fixed; (4) lathe turning, in which the plaster is pre-cast as a rough cylinder and placed on a lathe for finishing. In addition, there are several methods of shaping plaster by *rotating* the *template.* We will consider each method.

ROTATING THE PLASTER

Plaster-Wheel Turning

In this type of turning, plaster is cast in a coddle on what is simply called a plaster-wheel. A plaster-wheel is a metal wheel that has been covered with a plaster platform several inches thick, thereby differentiating it from a throwing, or potter's, wheel. The wheel is usually belt-driven by a standard electric motor, ¼ HP being sufficient. A speed control is necessary and is usually achieved by placing a rheostat on the line to the motor. The control of the rheostat should be within easy reach of the operator while at the wheel. With this type of control, it is advisable not to run the motor at slow speeds for any prolonged length of time, as overheating will result. The drive-belt should also be easily accessible to allow the operator to quickly engage or disengage power to the wheel.

The cast plaster is shaped while still *wet,* during the period of plasticity, with templates or plaster-turning tools. To give steady support to the operator's hands when using the templates or tools, a stick, commonly called a "belly-stick," is used. It is usually a wooden rod or dowel about 1 inch in diameter, much like a broomstick, with a headless nail driven into one end and a disk of wood or metal mounted on the other. The disk is attached in a way that allows it to move freely and swivel. The nail end is placed against a wall board behind the wheel and the operator places the disk against his chest (Figs. 261 and 262).

By leaning on the stick so anchored to the backboard, and by grasping the tools or template firmly against the stick, the operator obtains a mobile yet firm support that leaves him free to move laterally, and up and down, to control the position of his tools (Fig. 263). The stick provides a steady rest for the tool even as the operator moves up or down by bending or straightening his knees or moves laterally by shifting his upper torso to the left or right.

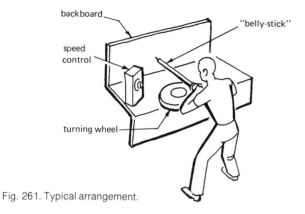

Fig. 261. Typical arrangement.

Fig. 262. Operator at the plaster-turning wheel.

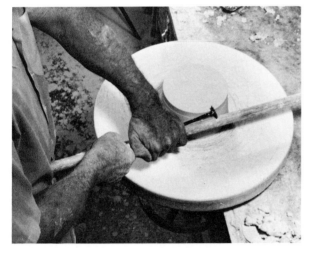

Fig. 263. Proper grasp of tool and stick. Tool shaft is under the stick.

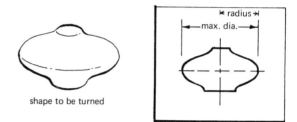

Fig. 264. Working drawing of sample piece. Divide the maximum diameter in half to get the radius.

Fig. 265. Mark the radius on the wheel with a pencil and turn the wheel to mark the circumference.

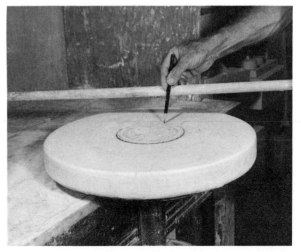

The first step in turning a plaster form on the wheel is to make a build-up — a circular platform on which to cast the plaster to be turned. Referring to a plan or a drawing of the piece to be turned, determine its maximum diameter (Fig. 264). It is often necessary to turn a piece in two sections, a top and a bottom, and to then glue the sections together. The maximum diameter is used whether the two pieces are symmetrical or not. Mark the *radius* of this dimension on the wheel with indelible pencil and draw the proper circumference by holding the pencil steady against the stick and rotating the wheel under it (Fig. 265).

101

Fig. 266. Place three nails in the wheel head within the drawn circumference.

Fig. 267. Clay the coddle placed around the drawn circle. Pour in plaster to cast platform ½ of an inch high.

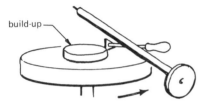

Fig. 268. When the plaster has set, trim this build-up to match the drawn circumference.

Prepare to cast a ½-inch high platform equal in circumference and diameter to the circle on the wheel by driving three roofing nails into the wheel head, leaving only ⅜ of an inch of each nail protruding (Fig. 266). These nails will firmly anchor the plaster to the wheel. Soap the wheel, place a soaped coddle around the drawn circle and the driven nails, clay the bottom seam, and cast the ½-inch platform (Fig. 267).

With turning tools, trim the circumference of the blank so that the pencil-line of the circle is barely seen when the size has been arrived at (Fig. 268). Plaster-turning tools are held firmly against the stick by placing the tool shaft under the stick and grasping the shaft with one hand while gripping the tool handle with the other hand. When the build-up has been trimmed to the proper circumference, soap it thoroughly.

Next, prepare the template. Again refer to the plan or drawing and determine the contour of the first piece to be turned (Fig. 269). Cut a template to this contour, allowing an extra ½ inch for the height of the build-up, and an extra 1½ inches to fold under at 90° to give a smooth support to the template against the surface of the wheel.

Fig. 269. Determine the contour of the first turning. Cut the template, allowing for build-up.

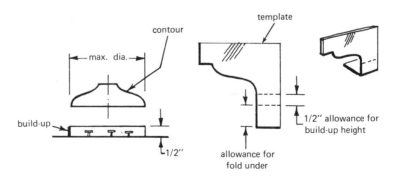

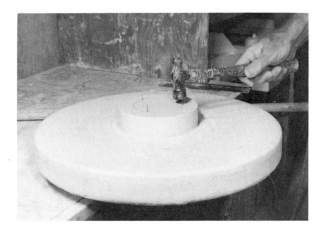

Fig. 270. Place three brads in the build-up.

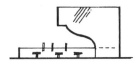

Fig. 271. Brads must be positioned so they will not engage the template.

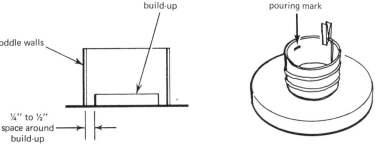

build-up

coddle walls

pouring mark

¼″ to ½″ space around build-up

Fig. 272. Place a coddle around the build-up and make a pouring mark. Clay the bottom seam. Coddle is not fitted flush against the build-up; an extra margin of plaster is cast so that the template can be moved in gradually.

When the template has been prepared, return to the wheel and build-up, and drive three small, headless brads into the build-up, making sure they do not protrude so far that they will engage the template when the plaster is turned (Figs. 270 and 271).

Wrap a coddle around the build-up, *not* in a snug fit, but at a distance of ¼ to ½ inch all around the build-up's circumference. Refer to the drawing and mark the inside of the coddle with the height of the piece to be turned, adding ⅛ of an inch to the measurement to allow for trimming (Fig. 272). Place clay around the seam of the coddle. Mix the plaster and pour to the mark.

Have the template and stick near at hand. When the plaster is just beginning to set, that is, just barely able to support itself, remove the clay seam and slide the coddle up and off the plaster cylinder (Fig. 273). Do not take time to unwrap the coddle as you would on an ordinary cast; here speed is of the essence and seconds count.

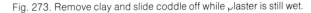

Fig. 273. Remove clay and slide coddle off while plaster is still wet.

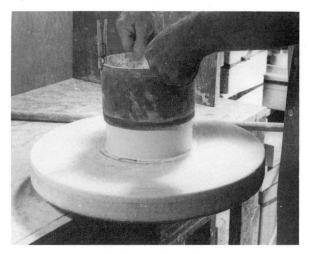

Start the table turning at a very slow speed. Holding the template with your hand supported against the stick, move it in to intercept the turning plaster. Do not attempt to take off all of the plaster in one try, but gradually move in toward the build-up, frequently wiping the plaster from the template (Fig. 274).

Gradually increase the turning speed and move the template in toward the center of the form until the template meets the side of the build-up (Fig. 275). The turning should now be the correct size. Stop the wheel and check the top of the piece against the required dimensions given on the drawing, using calipers (Fig. 276). Make any further adjustment cuts as necessary.

When the final size has been reached, let the plaster sit for a few minutes, then sprinkle it with a few drops of water (Fig. 277), and reapply the template. Since the plaster has expanded, you will be able to take off a few thousandths of an inch more, and at the same time impart a smooth surface to the piece.

Stop the wheel and draw an indelible register line on the side of the piece and the side of the build-up as a guide in the event you must later reposition the turning on the wheel (Fig. 278). Remove the piece gently, and withdraw the brads (Fig. 279).

Refer to the drawing for the shape of the bottom piece to be turned and, using the same build-up, repeat the same steps as before to produce this new section.

When finished, glue the two halves together and trim the completed model (Fig. 280).

Plaster-wheel turning is the trickiest of all the turning methods because so much has to happen in a short period of time. Yet it remains one of the best methods to obtain a model or model section, especially one which is not higher than 8 or 9 inches. Models over this height run the risk of deflecting under the sideways pressure exerted by the template or tool, and will begin to chatter; for turnings greater than this size, the lathe should be used. (See pages 107 to 113.)

Fig. 274. Ease template in toward center of form.

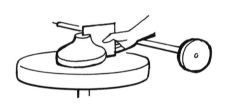

Fig. 275. Continue turning until the template engages the edge of the build-up.

Fig. 276. Check the dimensions of the turning against the working drawings.

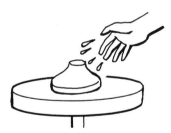

Fig. 277. Sprinkle the turned form with water lightly and reapply the template briefly.

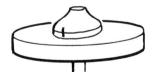

Fig. 278. Mark register lines on sides of piece and build-up.

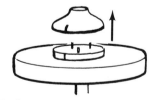

Fig. 279. Carefully remove the turning. Repeat the same steps to obtain a turning of the second half of the model.

Fig. 280. Glue the two halves together.

bridge can move
up or down
on pipe supports

Fig. 281. Typical turntable.

Fig. 282. Template in position; plaster is troweled onto work area.

Fig. 283. Add plaster in voids as they occur and continue turning.

Turntable Turning

Here the wet plaster is rotated at a slow speed, either by hand or power, under a fixed bridge holding the template.

If a turntable is not available, a simple one can be constructed with a round, wooden platform mounted on a central shaft or pivot, over which a bridge can be erected and braced. With metal pipes used as vertical supports, the horizontal bridge can be raised or lowered to the desired height before the template is fixed in position (Fig. 281).

To use the turntable, fix the template in position on the bridge. Measure the diameter and then mark the radius and the circumference of the desired piece on the platform as before. Mix the plaster and trowel it onto the work area — no build-up is used in this case, although it may be if desired. When the approximate height and circumference of the piece to be turned have been reached, rotate the platform and make the first cuts into the wet plaster (Fig. 282). Keep removing the scraped excess plaster from the front of the template. Continue to rotate the platform, adding wet plaster in the voids as they occur (Fig. 283).

When the shape has been acquired and the plaster is firm, a smooth, finishing coat may be obtained by sprinkling the surface with a few drops of water before making the final passes. Then raise or remove the bridge before removing the finished piece.

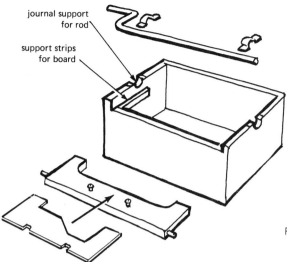

journal support for rod

support strips for board

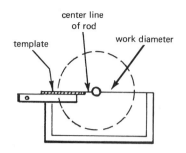

center line of rod

template

work diameter

Fig. 284. Turning-box assembly.

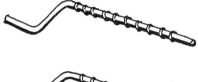

Fig. 285. Turning rods.

Fig. 286. Template and assembled box.

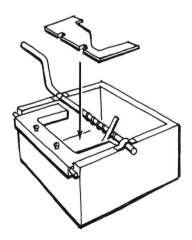

Box Turning

In this method, the wet plaster is applied to a metal rod which lies horizontally in a box. The rod is usually turned by hand although, for large installations, power may be necessary. The template is affixed to a board which fits into the box horizontally, parallel to the rod but slightly below it, so that the template will be on exactly the same plane as the horizontal center line of the rod (Fig. 284).

The box may be built to accommodate nearly any size desired; the only requirement is that the work and rod be adequately supported, usually by journals or bearings.

For the average work, the rod is wrapped with cord, which is wound the length of the rod much like the threads of a screw. This helps to keep a bond between plaster and turning rod. If it is possible to use the finished piece with the rod still in it, a crossbar can be welded to the rod wherever large masses are to be formed (Fig. 285). Obviously the rod cannot be removed with the crossbar so fixed.

The template may be fixed to the board with screws, or it may be fastened with bolts and washers fitting into slots cut along its edge as in using the jack (Chapter 9). The template should align with the center of the rod (Figs. 284 and 286). With the wrapped rod dropped into its journals,

mix a batch of plaster that has a little more plaster than normal added to the water. Apply this "short" mix to the rod, the stiffer mix functioning as a base for subsequent applications (Fig. 287). Do not attempt to make this first mix reach the template size; it is only to bulk out the rough figure. Do not apply too much plaster at one time, causing it to sag under its own weight, as this will ruin the bond to the rod, and work would have to start over.

Quickly, mix a second batch of plaster of normal consistency, and apply it over the first layer, building it up to the template with a spatula. Slowly rotate the rod and begin cutting by sliding the template board in toward the center. Remove excess plaster as it accumulates on the blade. Keep adding plaster to the voids until the piece is finished (Fig. 288).

Note that, if the piece has very large masses, when the normal plaster mix is applied, these areas should be held back from the template a slight bit because they expand more than the smaller areas do and at a slower speed. After most of the piece has been turned and the large areas have expanded, you can roughen the surface of the piece and, with the spatula, apply a final coat of plaster, sprinkling it with water to achieve a smooth finish.

The finished piece is removed from the box by lifting the rod up and out of its journals. The rod may be removed from the turned plaster by twisting and pulling it, provided a crossbar has not been used.

Lathe Turning

In this method a rough cylinder of plaster is cast and placed on a lathe in order to be turned with tools or templates. The use of this method is restricted, naturally, to forms falling within the size limitations imposed by the bed length and the swing diameters. A standard wood-turning lathe is quite adequate, with a standard headstock live center and with a dead center in the tailstock (Fig. 289).

When it is known that lathe turning will be required, the first step takes place several hours before the turning is to be done. This involves soaking a piece of doweling (usually ¾ of an inch in diameter) in water for an hour or more. Since plaster wears away rapidly, it is impractical to try to drive it with the blades of the live center; therefore, a wooden core is cast into the plaster to give the blades something firm to bite into. The dowel is soaked so as to absorb water and swell in size *before* being cast in plaster. If the dowel is not soaked beforehand, it will absorb water from the plaster cast around it and then swell, ruining the cast.

Refer to a plan or drawing of the piece to be turned and cut a length of dowel ¾ of an inch *shorter* than the overall

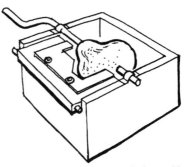

Fig. 287. Plaster partially applied to rod in box.

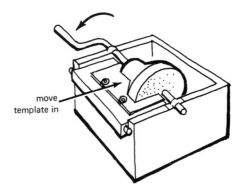

move template in

Fig. 288. Template is moved in toward center by operator as rod is turned.

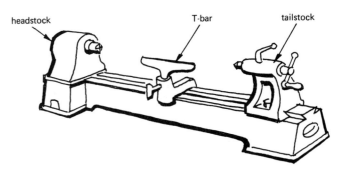

headstock T-bar tailstock

Fig. 289. Simple wood-working lathe set up for turning plaster.

107

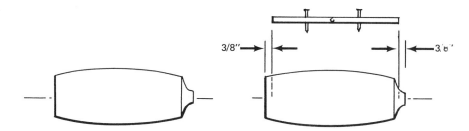

3/8'' 3/8''

Fig. 290. Plan of sample piece, showing appropriate dowel length.

length of the piece, subtracting ⅜ of an inch from each end (Fig. 290). Use ¾- or 1-inch diameter doweling unless you are turning something with a very small diameter; in that case, use a proportionally smaller diameter dowel. If the smaller dowel is used, a drill chuck in the headstock spindle will prove appropriate for holding the work, since the jaws of the chuck can be drawn down to tighten on the dowel. (Do not shorten the dowel in that case.)

Soak the dowel in water for a minimum of one hour — longer is fine. After it has been soaked, wrap it with cord (as the rod was wrapped for box turning) or drive several nails through it at points that will not interfere with the turning procedure (Fig. 291).

A good lathe-turning result depends on a well-prepared plaster cylinder blank on which to work; for a step-by-step description of preparing the blank, refer to Figures 292 through 310.

Fig. 291. Nails are inserted to hold plaster to dowel. One end of the dowel is tapered to accommodate narrow neck of this model.

Fig. 292. Center-punch both ends of the water-soaked dowel.

Fig. 293. At one end of the dowel, saw two ⅛ inch-deep slots, crossing at right angles. Drive a 1¼-inch headless nail firmly into the center-punched hole.

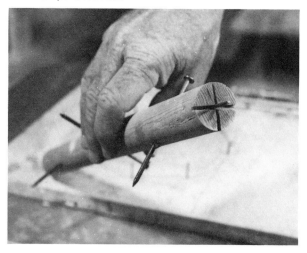

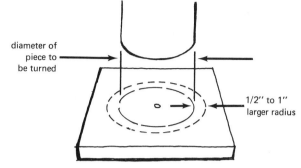

diameter of piece to be turned →

← 1/2" to 1" larger radius

Fig. 294. On a board, swing a circle with a radius ½ to 1 inch larger than the piece to be turned. Drill a hole in the center of the circle to receive the nail in the dowel.

Fig. 296. Make certain the board is level on a flat work surface.

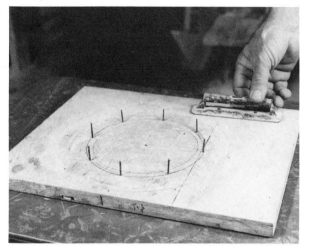

Fig. 295. Around the drawn circle, drive headless brads, slanting them slightly outward to receive and hold a coddle. Soap the board.

Fig. 297. Fit the nail at the end of the dowel into the center hole. Tap the dowel firmly into place, leaving a ¼-inch space between the bottom of the dowel and the top of the board.

Fig. 298. Into the ¼-inch space, wedge a ring of soft clay.

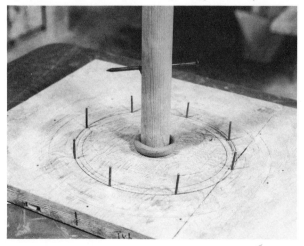

Fig. 299. With a square, make certain the dowel is perpendicular to the platform; trim the clay ring.

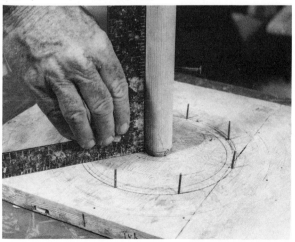

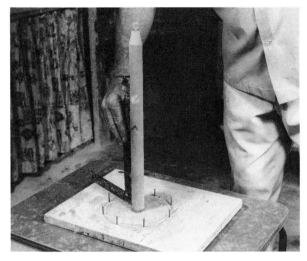

Fig. 300. On the top of the dowel, place a small plug of clay, ½-inch thick. Check to see that the dowel is still perpendicular.

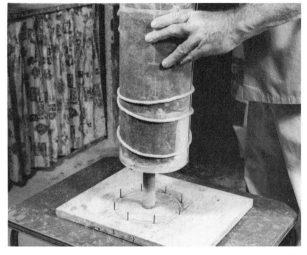

Fig. 301. Prepare a tall coddle of linoleum, making sure it is the proper length for the piece to be turned and that its circumference fits snugly inside the ring of headless brads. When the soaped coddle is ready, lower it carefully over the dowel.

Fig. 302. Press the coddle firmly into position inside the ring of brads.

Fig. 303. Check the dowel to see that it has not moved.

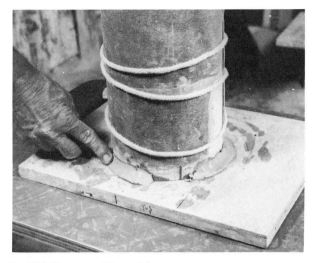

Fig. 304. Clay around the coddle seam.

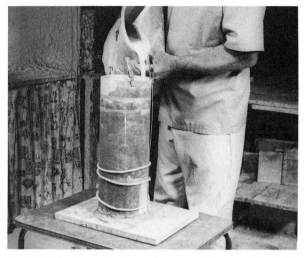

Fig. 305. Mix plaster and pour, being careful not to disturb the dowel.

Fig. 306. Pour until the top clay plug is barely covered.

Fig. 307. When the plaster has set, remove the top clay plug with a knife.

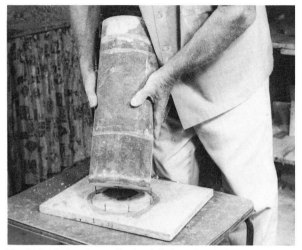

Fig. 308. Lift the plaster-filled coddle from the platform.

Fig. 309. Remove the coddle.

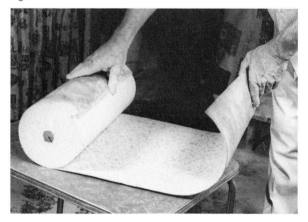

Fig. 310. Remove the nail and clay from the bottom of the dowel, revealing the crisscrossed end.

After the plaster cylinder has been formed, it is fitted between the centers of the lathe with the slotted end of the dowel against the blades of the live center on the headstock (Fig. 311). Adjust the tailstock to exert pressure on the doweling core, forcing the blades of the live center to bite into the crisscrossed end (Fig. 312).

Fig. 311. Cylinder is placed between the lathe centers with slotted end of dowel facing headstock.

Fig. 312. Cylinder in position on headstock end.

112

Fig. 313. The cylinder ready to turn.

Fig. 314. The first rounding cuts are made quickly to achieve a smooth-running cylinder.

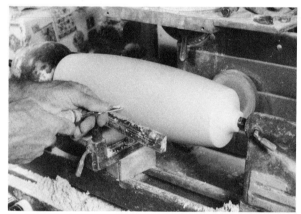

Fig. 315. The form emerges.

Fig. 316. The finished piece.

The plaster is now ready to turn (Fig. 313). The first cuts should be made quickly but with the lathe running at slow RPM's, using a chisel or similar wide-bladed tool to remove the shoulder of plaster made by the coddle. Uniformity of roundness is to be achieved as soon as possible because off-center weight will tend to tear the cast loose from the centers when running at speed.

When a smooth-running cylinder has been acquired (Fig. 314), refer to the working drawing and remove plaster as needed, using templates, chisels, and assorted wood-turning tools, and making use of the T-bar as a tool rest (Fig. 315).

When the basic form has been achieved, use various grades of sandpaper to put a smooth surface on the finished model (Fig. 316). Remove the model carefully.

ROTATING THE TEMPLATE

Instead of rotating the plaster on a wheel, rod, or lathe, the template may be rotated while the plaster remains stationary. In this case, the template is fixed to a jack, or to a rod, which can be rotated.

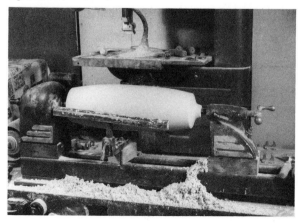

Fig. 317. Template is mounted to block of wood.

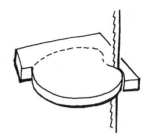

Fig. 318. Platform for the piece to be turned is sawed from plaster or wood.

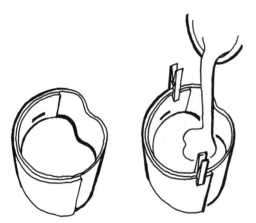

Fig. 319. Coddle is made to conform to the platform's shape and cast is made.

Fig. 320. Coddle is slid up and off while plaster on the platform is still wet.

Hand Scraping

The template is fastened at a right angle to a block of wood, forming a simple jack (Fig. 317) which the operator moves around the plaster in a process similar to running a length of plaster with a jack. To provide a guide for the jack, the outline of the form's base is transferred to a suitable material, such as wood or plaster, from which a platform of the same shape may be cut. The vertical edge of the platform will act as a guide, allowing the template and block of wood to follow the shape of the piece. The wet plaster, which is cast on the platform, is thereby trimmed to the desired shape. When the platform has been sawed out to the shape (Fig. 318), use files and sandpaper to smooth the bearing edges.

To cast the desired form, wrap a soaped coddle around the platform, marking the proper height inside the coddle.

Fig. 321. Template is brought to bear against platform's edge. Using a plaster-wheel simplifies the scraping operation.

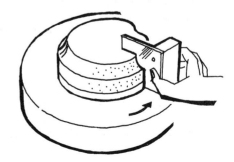

Mix and pour the plaster to the mark (Fig. 319). Remove the coddle as soon as the plaster is firm enough not to sag (Fig. 320). Bring the template up to the plaster and, using the platform edge as a guide, move the template around the form, carefully moving the form with one hand while scraping off the wet plaster with the template block in the other hand. Keep wiping the template clean as you proceed. Continue to scrape around the platform until the desired form is reached.

Since this is basically a two-handed operation, it is much easier if the platform is about an inch thick, in order to have something to grasp and turn as you move the template around it. Also, performing this operation on a soaped plaster-wheel will enable you to revolve the work in front of you with even greater ease (Fig 321).

This type of scraping can be done on dry as well as wet plaster, and on shapes other than round.

Drill Scraping

Here a pre-cast piece of plaster is scraped to the desired depth by a template that has been attached to a piece of drill rod and whirled under power.

Cut the template and weld it to a section of drill rod of the proper diameter for your drill, usually ¼-inch diameter. Bend the top edge of the template to stiffen it (Fig. 322). Insert the rod in the drill press or hand drill and bring it to bear against the surface of the plaster piece. Increase the pressure and depth until the turning is completed (Fig. 323). This method is best suited for use on dry plaster.

Bench Turning

In this method, the template is attached to a jack which is revolved around a pivot. The plaster to be formed is troweled onto the work surface in a circular area surrounding the pivot.

To begin, fasten a flange with a threaded hole into a work surface such as a piece of ¾-inch plywood. A length of threaded rod to be used as the center post for the jack may then be screwed into the hole (Fig. 324).

A jack or sled is then made in which the template arm will act as a bridge leading to the pivot rod. By attaching

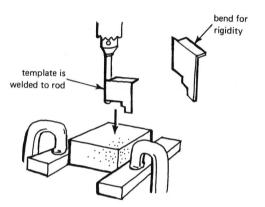

Fig. 322. Plaster blank can be clamped on drill press.

Fig. 323. Template in chuck is lowered to engage the blank.

Fig. 324. Center post fits in flange in board.

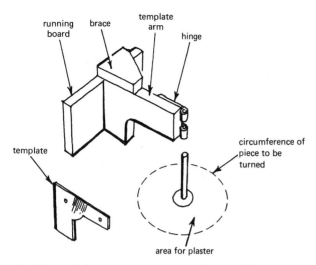

Fig. 325. Jack fits over center post and is rotated. Template is fastened to the arm and plaster is troweled onto the board.

Fig. 326. Jack with template on it is turned while plaster is stationary.

one section of a loose-pin hinge to the template arm so it overhangs the end of the arm, a convenient and solid pivot mechanism can be made. Cut the desired template and fasten it to the arm (Fig. 325).

Using the pivot post as the center, mark the circumference of the piece on the work surface. Mix the plaster and trowel it onto the board within the marked area. Rotate the template arm several times to shape the mass roughly. Keep the template clean. Using a spatula, apply plaster to the void areas and continue scraping, alternating these two procedures, until the finished piece is acquired (Fig. 326). When the piece is finished, the center hole left by the pivot post may be filled with plaster and screeded flush.

It is also possible to do dry turning with this setup. The plaster must be drilled first to take the pivot, and the base of the piece should be fastened in position with glue or by claying around the periphery. The template is then rotated as in wet turning and the plaster is gradually scraped away until the desired profile is reached.

11. Model Problems and Solutions

THE PRINCIPLE OF NEGATIVE SPACE

Since you, the reader, are involved with art in some form, the term "negative space" is probably not new to you; it is used quite often in dealing with the graphic image. Negative space means the space *around* a given object. In model-making, too, it has a similar meaning, only more so — it literally *defines* the space around an object; it *limits* the shape, *determines* the shape of an object.

If a circle is drawn within a square, it can be viewed in one of two ways: The first is to see only the circle for what it is; the other is to see the space around the circle as that which gives it form. This is an example of the negative space (Fig. 327).

A plaster mold can be considered the embodiment of this negative space — it literally, physically limits the shape which can be made from it.

As we progress in model construction, we see this interdependency of negative space and positive form being used more and more; many otherwise difficult modeling situations become relatively simple by applying the principle of negative space to obtain the desired form. Thus the craftsman will come to realize that the cavities in a model may be obtained indirectly by incorporating positive forms in a mold, and that some models may be formed entirely by defining the negative space around them. The processes of mold-making and model-making are interacting ones. Molds may be used not only to reproduce the final model but to construct the original model as well.

AN EXAMPLE OF NEGATIVE SPACE APPLIED

Suppose we wish to produce a cube with a conical depression in one side (Fig. 328). At first glance, we would be tempted to think about producing the cube itself first, probably by sawing it out of solid plaster and then somehow carving out the hole — either by drilling or by turning the piece on a lathe.

Fig. 327. Negative space forms the circle on the right.

Fig. 328. Desired cube with conical depression.

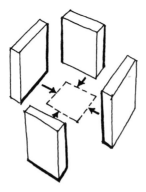

Fig. 329. Four pieces on marble can form a mold for the basic cube.

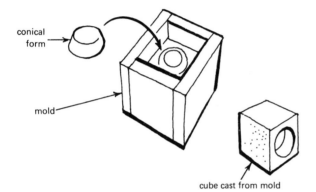

Fig. 330. A cone the size and shape of the desired conical depression is glued to the marble within the mold. Cast produces desired piece.

However, if we become accustomed to thinking in terms of negative space, a simpler solution lies in planning to make the hole as a physical solid, a positive form, a part of the defining material surrounding the cube.

With this in mind, we take two simple steps: First, we clamp plaster pieces together to form a cubical box, open at the top for pouring and self-leveling (Fig. 329); second, we produce a cone the size and shape of the conical hole desired. We may turn the cone from plaster or wood or clay, on the lathe or the wheel, and glue it into position within the clamped-together mold (Fig. 330). We then pour plaster into the mold and the resultant cast is the cube with the conical depression in its side.

Thus, in many instances, the consideration of the negative-space principle can be the key to the most satisfactory method of producing the desired model. Whenever you are faced with a problem involving the casting of a cavity, try this analysis first. Quite often it is the easiest and most direct way to a solution.

A SMALL SOAP DISH

This model (Fig. 331) will show how a carved design can be incorporated into a piece by using the negative-space approach. The basic form of the dish itself is turned on the wheel in two sections. A mold is made of the top section and a separate, positive piece corresponding to the recess is glued in the mold as an insert. A cast is then made of the mold and insert to obtain the final, recessed model section. Changes in carved design can thus be accomplished by simply changing the insert when casting the top section. The bottom section, which is simply turned on the wheel, is glued to the finished top section to form the complete model.

Fig. 331. The completed plaster model obtained from working drawings.

Fig. 332. Given working drawings of a soap dish, determine the maximum diameter. The plan and elevation show the decorative recess in the top of the model.

(Note: When the model is to be reproduced as ceramic ware, always check the drawings to determine whether they are drawn to the scale of the plaster model or to the intended size of the fired piece. Since ceramic shrinks in firing, model-size drawings are preferred; otherwise, if the drawings are made to the size of the fired piece, the percentage of shrinkage must be calculated and compensated for in making the model.)

Fig. 333. On the soaped plaster-wheel, cast a build-up ½-inch high over three large-headed nails driven into the wheel head. The diameter of the build-up should be the same as the maximum diameter of the model to be turned. Mark the radius and then the circumference on the wheel with indelible pencil and cast the build-up as in Chapter 10.

After the build-up has set, drive three small, headless brads into it, to anchor the first piece to be turned.

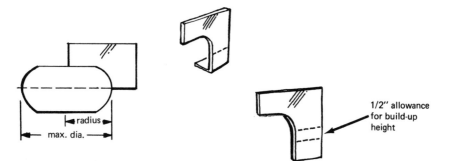

Fig. 334. Referring to the working drawing, trace the contour of the top portion of the dish to be turned and cut a template for it. In cutting the template, be sure to allow an extra ½-inch for the build-up height, and an extra bit for the fold-back.

Soap the build-up on the wheel and cast plaster to the height needed for the first turning. Be sure to make the coddle 1 inch larger in diameter than the build-up so the coddle wall is ½ of an inch away from the build-up's circumference.

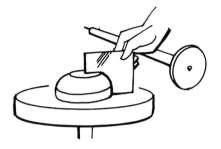

Fig. 335. Remove the coddle when the plaster just sets. Using the template, turn the first half of the model as described in Chapter 10. When the proper contour is acquired, let the plaster harden.

Fig. 336. Remove the turned section from the build-up. Remove the three small brads from the plaster build-up, but leave the build-up on the wheel.

cast one-piece
mold over turned
piece

Fig. 337. Soap this turned section and place it on the marble; place soaped boards around it and cast a one-piece mold over it.

Fig. 338. When the cast has set, invert the mold and carefully remove the model half.

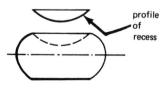

profile
of
recess

Fig. 339. Refer to the working drawing and trace a profile of the curved recess in the model's top. The next step is to cut a template for this profile and turn a positive form of the recess.

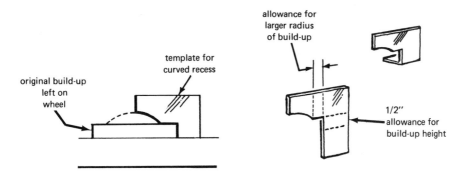

Fig. 340. Plan to use the same build-up as before. Allow for both the height of the build-up and its larger radius when cutting the template for the recess profile. Also allow for a fold-back.

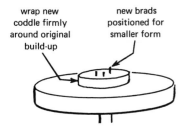

Fig. 341. Into the build-up, drive three appropriately sized, headless brads to a height that will not project when the recess is being turned. Soap the build-up.

Wrap a soaped coddle firmly around the build-up and cast plaster to the height of the recess to be turned.

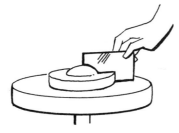

Fig. 342. While the plaster is still in a state of plasticity, turn the recess' shape, moving the template in toward the build-up gradually.

Fig. 343. Allow the turned form to harden; then remove it from the build-up. Remove the brads.

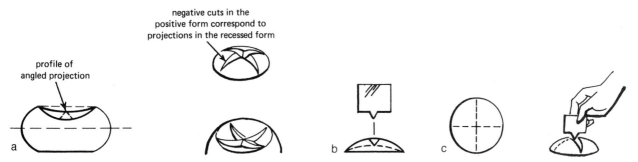

Fig. 344. (a) Referring to the working drawings, note how the angled projections desired on the final model can be translated into negative notches in the positive form. (b) Cut a template conforming to the profile of the angled projections. (c) Mark guidelines on the top of the small, turned form and, following the guidelines, carve a V-shaped design corresponding to the angled projections.

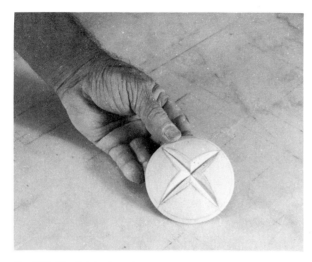

Fig. 345. The finished carving.

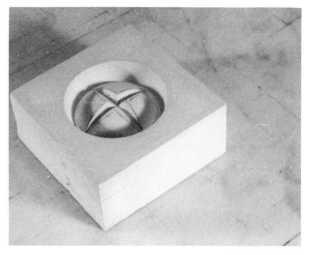

Fig. 346. With Duco cement, glue the carved recess into the bottom of the mold cast from the previously turned top section. Soap the mold and the insert.

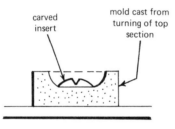

carved insert

mold cast from turning of top section

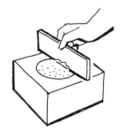

Fig. 347. Mix plaster and fill the cavity to slightly overflowing. Screed smooth.

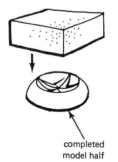

completed model half

Fig. 348. When the plaster has set and cooled, invert the mold and carefully remove the cast. This is the completed model half.

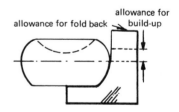

allowance for fold back

allowance for build-up

Fig. 349. Refer to the working drawing and make a template of the profile for the bottom half of the dish. Allow for the build-up height and for a fold-back when cutting the template. The same build-up used for the top section of the dish is used here once again.

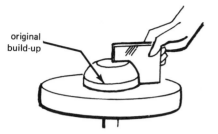

original
build-up

Fig. 350. Resoap this original build-up, position new brads to anchor the plaster and cast plaster within a coddle placed loosely around the build-up as before. Turn the bottom shape.

Fig. 351. When the section has been turned, remove it from the build-up; remove the brads, and glue this section to the completed top half.

Fig. 352. The finished product — a ceramic soap dish — obtained from production molds made of the model.

A SCROLL-SHAPED CLOCK

The unusual feature of this model (Fig. 353) is that it is formed entirely from extrusions of plaster run with the jack. Three runs are made: The first forms the front of the clock; the second forms the dial-insert cavity; the third forms the back surface.

Fig. 353. The finished plaster model of clock made by running sections with a jack.

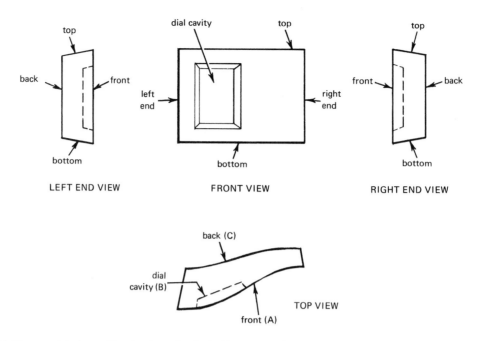

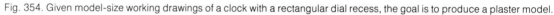

Fig. 354. Given model-size working drawings of a clock with a rectangular dial recess, the goal is to produce a plaster model.

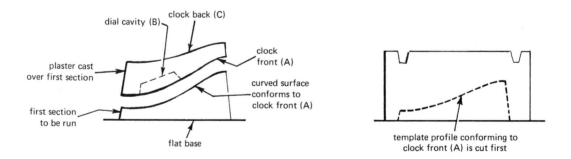

Fig. 355. Using the drawings for reference, plan the sequence of extrusions. Note that both the front and back contours are curved. Since extrusion takes place on a flat surface, the first section to be run will be merely a base section, with a flat bottom and a curved top surface, over which all successive casts and runs will be made. This curved top surface acts to define surface "A", the front face of the model. Note that the clock is planned to be run front-face down.

To obtain a template profile for this first, base section, trace the curve of the clock front (A) onto the metal, leaving a minimum space of 1 inch between the curve's lowest point and the bottom edge of the metal. Extend the end lines of the clock down to the bottom of the metal as indicated by the dashed lines. This profile is then cut as the first template. Each succeeding profile will be cut on the same template, each change being made after the previous section has been run.

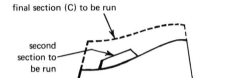

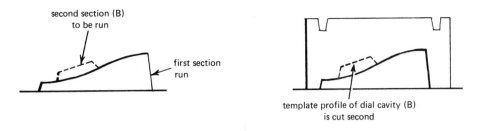

second section (B)
to be run

first section
run

template profile of dial cavity (B)
is cut second

Fig. 356. Plan the contour of the dial cavity (B) as the next shape to be run. When this shape is extruded and trimmed it will be glued onto the first section run.

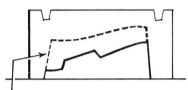

final section (C) to be run

second
section to
be run

template profile of clock back (C) is cut last

Fig. 357. Plan the contour of the model back (C) as the final extrusion. When trimmed, this section will actually be the body of the finished model. The front surface and the dial cavity are formed by casting the plaster against the defining shapes of the first and second extrusions; the back and two end surfaces are formed by the template for this last extrusion, which conforms to the rear profile.

cut profile of front face (A)

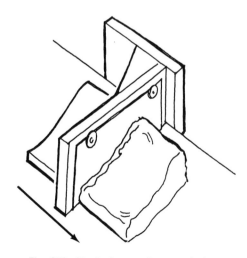

Fig. 358. Accordingly, cut the first template.

Fig. 359. Attach the template to a jack; mix and cast the plaster, and run the first extrusion.

125

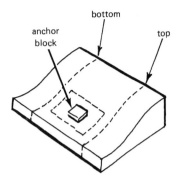

anchor
block

bottom

top

Fig. 360. Referring to the drawings, draw lines on this extruded piece indicating the top and bottom of the clock. Locate and draw the rectangle of the dial cavity that is to be formed. Then glue a small anchor block of wood or plaster within the dial area to hold the plaster to be extruded over it. Soap the entire first section thoroughly.

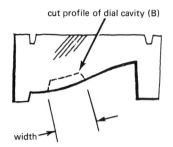

cut profile of dial cavity (B)

width

Fig. 361. From the same template, cut the profile of the dial cavity (B).

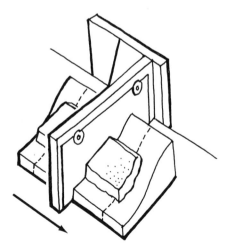

Fig. 362. Mix and trowel the plaster onto the first extrusion, in the area of the dial cavity. Run the short section, extruding the dial profile to its proper width.

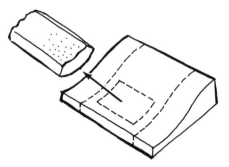

Fig. 363. When the plaster has set, remove the extruded dial section. It now must be sawed to its proper length.

126

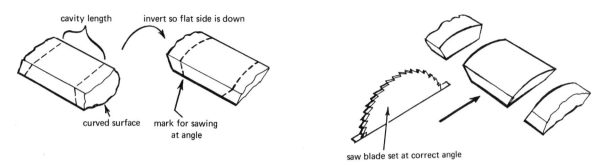

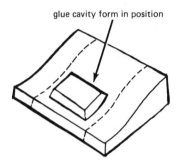

Fig. 364. Referring to the drawings, measure and mark the length of the dial cavity on the extruded piece. Place the extrusion flat-side down on the bed of a table saw. Set the saw blade at the angle planned for each end of the dial and cut the extruded piece to its proper length.

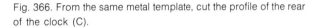

Fig. 365. With the dial cavity cut to its correct size, glue it in position on the first section run and soap the entire form thoroughly.

Fig. 366. From the same metal template, cut the profile of the rear of the clock (C).

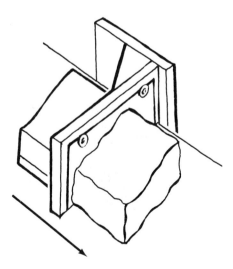

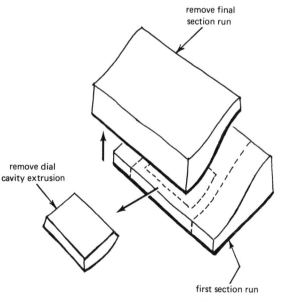

Fig. 367. Mix plaster and cast it over the combined extrusions of front profile and dial profile. With the jack, run the rear profile extrusion.

Fig. 368. When the plaster has set, remove this last extrusion, which will provide the body of the finished model. Remove the dial-cavity extrusion from the first section run.

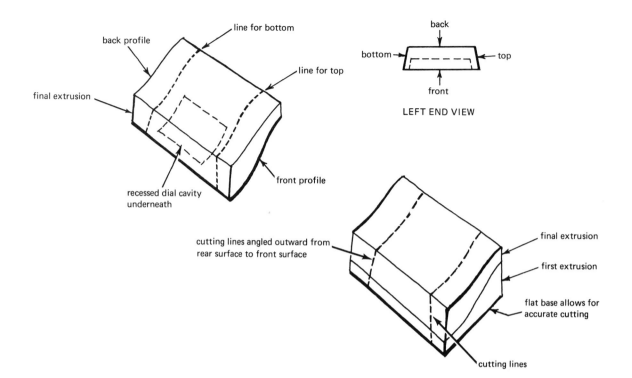

back profile

line for bottom

line for top

final extrusion

recessed dial cavity
underneath

front profile

back

bottom → ← top

front

LEFT END VIEW

cutting lines angled outward from
rear surface to front surface

final extrusion

first extrusion

flat base allows for
accurate cutting

cutting lines

Fig. 369. (Above) Draw lines on the final extrusion indicating the top and bottom of the clock. (Refer to the working drawings.) Since there is a slight angle on the top and bottom surfaces of the clock, these must be accomplished on the extruded model. To aid in sawing, replace the third extrusion on the first section run, which has a flat base. Carefully saw the model on the lines indicated. The trimmed, final extrusion is the finished model.

Fig. 370. (Right) The ceramic version of the finished plaster model shown on page 123.

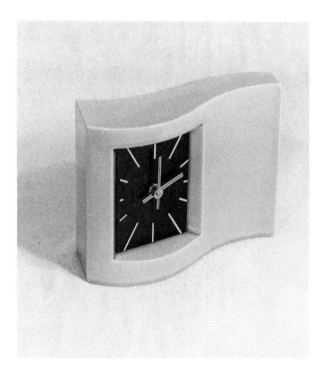

A CLOCK PLANTER

The model of this clock (Fig. 371) has two features — it shows how a symmetrical design can sometimes be thought of as the combination of two identical halves and constructed as such; it also shows how a recess for the dial can be made with negative space.

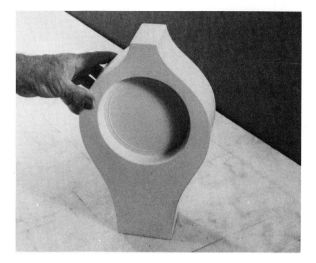

Fig. 371. The completed plaster model obtained from working drawings.

Fig. 372. Given model-size drawings of a clock with a round dial cavity, the goal is to produce a plaster model.

Fig. 373. Referring to the drawings, trace onto stiff cardboard the profile of one half of the model. Cut this shape from the cardboard.

Fig. 374. Using the cardboard as a guide, trace this shape onto the marble work surface.

Fig. 375. Place the guide to one side and build a small wall of clay around the tracing on the marble; make the wall about ⅜ of an inch in height. Soap the marble surface. Mix plaster and pour into this form.

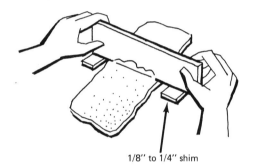

1/8″ to 1/4″ shim

Fig. 376. When the plaster is just barely able to hold its own shape, the following actions must take place rather quickly: Remove the clay walls and, with a metal straightedge resting on two shims approximately ⅛ to ¼ of an inch tall, screed the plaster smooth.

Fig. 377. While the plaster is still wet, place the cardboard guide on the plaster surface.

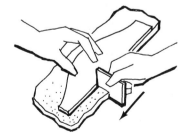

Fig. 378. Using the cardboard as a template, and a small straightedge as a tool, scrape the plaster to the shape of the template.

Fig. 379. When the plaster has set, smooth the edges of the hardened shape with sandpaper wrapped around a block of wood.

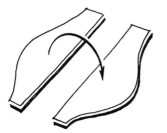

Fig. 380. When the edges are smooth, invert the shape so that the marble-smooth surface is up. We now consider this to be a plaster template, and glue it to the marble, smooth surface up.

The objective here is to cast a model half from which two identical mold halves may be cast. The model half is cast first by constructing a mold around the plaster template.

Figs. 381 and 382: To make the mold, use three rectangular pieces of plaster cut to the desired height of the model, and assemble these around the template — leaving the curved side open. Soap all the pieces, including the template, before assembling them.

Cut an extra rectangular piece of plaster of the same height to serve as a brace for the scraper when screeding off the top of the cast.

Fig. 383. Prepare a piece of soaped linoleum, bending it to follow the contour of the template. Heating the linoleum before soaping will make it more flexible.

Fig. 384. Clamp all pieces together to form a mold for the model half. Mix plaster and pour to slightly overflowing.

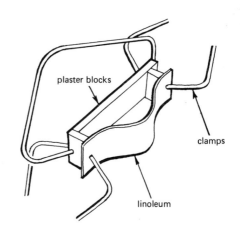

plaster blocks

clamps

linoleum

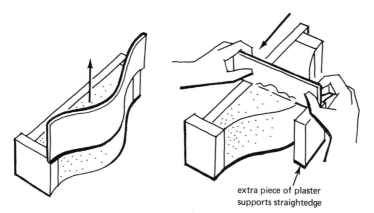

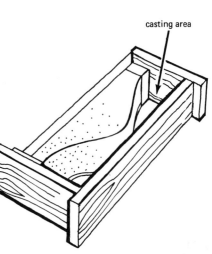

casting area

Fig. 385. When the state of plasticity has begun, unclamp the form and slide the linoleum up and off the plaster.

Fig. 386. With a straightedge, quickly screed off the top surface, using the extra piece of plaster to support the straightedge.

extra piece of plaster supports straightedge

Fig. 387. While the plaster is still plastic, use a scraper to follow the curve of the template.

When the plaster has set, remove the cast model half and sandpaper all its surfaces. Then soap the cast piece and replace it on the template, which should still have the plaster blocks positioned around it.

Fig. 388. Place soaped boards around the blocks and the model half on the template to form the casting area indicated. Clamp and clay the boards.

Mix plaster and pour to a height of ⅛ of an inch above the model half. Carefully screed the plaster flush, using a straightedge resting on the model half.

Fig. 389. When the plaster has set, remove the boards and the newly cast piece, which is the first mold half. To cast the second mold half, repeat the steps given for Fig. 388, resoaping all plaster surfaces and boards before casting. When the plaster has set, remove the boards and the newly cast second mold half.

Referring to the working drawings, turn the shape of the desired dial cavity on the plaster-wheel. When this turning is finished, soap it and draw center lines on it.

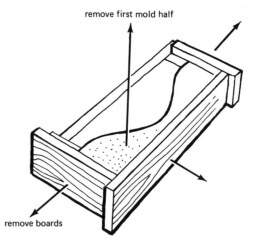

remove first mold half

remove boards

Fig. 390. Draw centering guidelines on the marble indicating the position of the dial cavity. Glue the cavity-turning face down on the marble in proper position on these guidelines.

Fig. 391. Since the model desired is laterally symmetrical, simply invert the second mold half and assemble the two halves in proper position around the dial cavity — using two rectangular pieces of plaster, cut to proper size, to form the spacers between the halves. Clamp the mold together firmly and soap the entire assembly and casting area on the marble thoroughly. Mix plaster and pour to a height of ⅛ of an inch above the mold. Screed flush.

Fig. 392. When the plaster has set, remove the mold halves and end pieces. Carefully lift the completed model and extract the dial-cavity turning.

Fig. 393. The finished ceramic piece made from the plaster model shown on page 129. Front and back openings were carved in the greenware.

12. General Notes

SHIM MOLD METHOD

In both the clay bed and plaster build-up methods, we are able to produce accurate piece molds that may be as simple or as complicated as the model demands. This enables us to extract the model intact and to use the mold as often as desired. There is another approach to model-making, one that is often used by sculpture students to reproduce models made of soft material such as clay, and that is to produce a waste mold. This type of mold does not require close attention to angles of withdrawal, although it does take into account draft and undercuts for large areas; it is made with the intention of using it only once and destroying it in order to extract the model cast within it. By using this method, a complicated model may be reproduced with a simple two-piece mold, but the original model is usually destroyed when the completed mold sections are removed and the model is always somewhat damaged by the line of metal shims inserted along the parting line as a physical barrier between mold sections.

The shims are rectangular pieces (approximately 2 by 3 inches) of thin, galvanized sheet metal or brass stock, and they are pushed firmly into the model along the parting line to form a wall at least 1½ inches high between the mold sections. When the wall is complete, a moderately thin mix of plaster with household blueing added is flicked over the model until there is a thin layer covering it. A second, thicker mix (uncolored) is then used to build up the thickness of the mold to the top of the metal wall, layer by layer. The top edge of the wall must remain free of plaster however. As no retaining walls are used, the outside walls of the mold are apt to be free-form rather than rectangular (Fig. 394).

When the plaster has set, the two mold sections are carefully pried apart along the shim line and the model is extracted. Any parts of the clay model remaining in the mold are removed, and the mold is soaped and reassembled for casting.

After the casting material has been poured into the mold and has hardened sufficiently, the mold is chipped away from the model within, with chisels and a hammer, until the colored layer of plaster has been reached. This is a visual warning layer; it is also chipped away, but much more carefully. Since the interior of the mold has been soaped, gentle tapping should remove the last layer without damaging the model inside.

For hard-surfaced models, clay fences must be used in place of metal shims and the mold must be made in several pieces in order to extract the model. The pieces would have to be reassembled and held together by a case for casting.

WASTE MOLDS

Most often, in professional mold-making, the piece mold that is cast from the original model is employed as a waste mold rather than as a model mold; that is, it is intended to

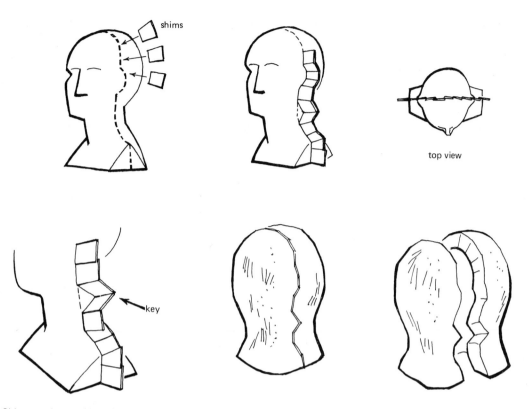

Fig. 394. Shims are inserted in soft-surfaced model along parting line to separate mold sections, and plaster is built up over the model in layers.

be used as an intermediary step between the original model and the piece of ware that is finally slip-cast in a production mold. The object of the waste mold is to produce a plaster model which can be perfected and from which a new mold can be made. This procedure provides a double opportunity to resolve any imperfections on the original model. Surface variations such as scratches on the original model may be corrected on the waste mold, where they appear as ridges that can easily be scraped off. In addition, the plaster model that is cast from the cleaned-up waste mold may be worked on further.

The perfected plaster model is then used to make a model mold. This is done in two steps (more if there are more than two mold sections). (1) One section of the soaped waste mold is placed on the work surface with the soaped plaster model in it. Boards are placed around the form and a mold section is cast over the exposed portion of the plaster model. At this point, the model is enclosed by one section of the waste mold and one section of the new

model mold (Fig. 395). (2) This unit is then inverted and the waste-mold section is removed and discarded. The first section of the model mold, with the model in it, is soaped; boards are placed around the form, and the second section of the model mold is cast over the newly exposed portion of the model.

Fig. 395. After the waste mold has been used to produce a perfected plaster model, that model and the waste-mold sections are used to produce the model-mold sections.

135

If production molds are required, a block and case is made from each section of the model mold, and production molds are then made from the blocks and cases. In some cases the model mold can also function as a production mold. In fact, if one is hesitant about making blocks and cases (one reason might be that the piece is being test-marketed before large-scale production), the procedure just described for making a model mold can be repeated to produce any number of molds to be used for limited production of the ware.

The difference between the waste mold used in this procedure and that which results from the shim-mold method of casting is that the latter mold is not planned to accommodate precise draft and all undercuts, while the former is. This means that, while the mold produced by the shim method must be chipped off to release the model and is destroyed in the process, the planned waste mold can be kept generally intact while removing the model, even when some difficulty in removal is encountered, and the mold can be reused.

REMOVING A MODEL

As previously mentioned, when casting a mold over a piece, it is usually no problem to release the piece, barring undercutting, because the plaster expands away from the model. However, when casting a model within a mold, the plaster of the model expands within the confined space and tends to wedge itself tightly in the cavity.

In most cases, the mold into which plaster is cast is a waste mold. The model mold is made by casting plaster over the plaster model and so presents no problem in releasing the model. In making blocks, Ultracal 30 is cast into the model mold and, as this material expands very little, there is also no difficulty in removing the mold. If the model mold is used to cast a clay-slip model, there is again no problem, since clay shrinks rather than expands. Once plaster is cast into a waste mold, however, hammering or sawing may be necessary to release the model.

Usually the waste mold will separate fairly easily if we wait several hours to let the plaster model cool and shrink from its expanded size and then use compressed air and tapping to open the mold.

Judicious tapping with a rubber mallet on the top and bottom of the mold combined with the use of compressed air (if available), directing the stream into the seam of the mold, generally succeeds in getting the mold apart. Sometimes hefty blows with the rubber mallet all around the mold exterior are necessary. In extreme cases, wedges

driven into the seam will start to open the mold. In all of these operations, care must be taken not to overly damage the mold, although some damage cannot be avoided.

Sometimes, one section of the waste mold will release from the model while the other will not. This can happen where expansion has occurred between two projections on the model, acting to bind the model at that point (Fig. 396). In these cases, sharp raps on the mold with a steel hammer may serve to jar the model loose. If this fails, it is necessary to carefully split the mold section to release the model. To split a mold, it is best to use a carpenter's saw, and to saw a slot in the mold section to within an estimated ¼- to ½-inch of the model (Fig. 397). Often, it is necessary to saw a slot on opposite sides of the mold.

Remove the saw and insert two straight-edged scrapers into the slot with a hammer. Drive a wedge, such as a knife blade, between the two scrapers until the mold can be heard to crack (Fig. 398). Tap the wedge once more to open the crack. This is a controlled splitting operation because the mold will always break at its weakest points — at the corners and at the saw cut. The model can then be released and extracted. Since this is a controlled splitting, the mold can be rejoined with clamps for additional castings when models of identical size are required.

Such breaking of the waste mold is common practice and should not disturb you. To the uninitiated, it at first seems a drastic step to actually saw into a mold that has been so carefully planned for and made; yet this is the function of the waste mold — to provide the model — and splitting it is still the simplest, most direct way to release a needed piece encased within.

In fact, after some experience has been gained, one can anticipate areas of the model which will probably bind in the waste-mold, and the mold may be sawed *before* the plaster model is cast. In that case, the plaster model expands and actually opens the mold as it does so, allowing for free release.

COMPRESSED AIR

As with certain other facilities that one should acquire if any sizable amount of plaster work is to be done, a source of compressed air, such as a small, portable utility compressor and tank, proves invaluable. Directing the air-stream into the seam between two sections of a mold can help to open the mold; directing the stream along the periphery of a model half buried in a stubborn waste mold can help free it. Usually a pressure of 50 lbs. is suitable for this work.

Fig. 396. Expansion of plaster may cause part of the plaster model to become wedged in a mold section.

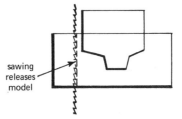

sawing releases model

EXPANSION OF PLASTER

Up until now, the expansion of plaster has been viewed from the standpoint of being a problem of mold release; now we must say a few words about it in terms of size change. Whenever plaster is cast, it expands, even after cooling, a very small amount — several thousandths of an inch. This may never become a problem for you; but it must be remembered under certain circumstances, especially when castings must be identical in size.

If we cast a waste mold over an original model, the waste mold expands these few thousandths of an inch; when a plaster model is cast in the waste mold, it, too, will expand this minute amount. So, in just two steps of casting, the plaster model is larger than the original by the total of these two expansions. Then, if a model mold is made over the plaster model, it expands, and you have a mold that has three expansions in it.

This cumulative expansion factor usually comes into play when item sizes must be matched, such as the left and right halves of a model. Although nothing can be done to reverse the size progression, one can control the matching factor by always making the same number of casts for each piece, thereby assuring the same number of expansions will be incorporated into the final casts.

TROUBLE SPOTS

Whenever there is difficulty in removing a model from a mold, always check the mold afterward to see if there are any undercut areas, or any sections which have frayed off or broken away in removal. If there are any small projections in the mold that interfere with withdrawal, be sure to remedy these by scraping and sanding before recasting.

Fig. 397. To release model, saw a slot in the mold section.

Fig. 398. Insert two scrapers into the slot and drive a wedge, such as a knife blade, between them. This splits the mold in a controlled way and the mold can be reused.

Fig. 399. Remove a spare from the mold section cast around it by inserting a knife in the center.

Fig. 400. Plaster curves up against casting board and becomes a sharp edge on the mold. Remove sharp edges by scraping them.

```
board ─┐          ┌─ cast plaster
```

```
sharp edge ─┐          scrape away
                       from edge
```

Fig. 401. Use a rotary motion and always scrape away from the sharp edge. If plaster surface is to the right of the sharp edge (a), use a counterclockwise motion. If plaster surface is to the left of the sharp edge (b), use a clockwise motion.

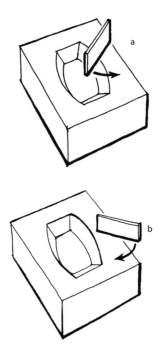

REMOVING THE SPARE

It is often necessary to cast around a spare when making a mold section or a block. To remove the spare from the surrounding cast, it is common practice to drive a narrow knife blade into its center and then tap sharply with a hammer. This usually frees the spare piece for withdrawal (Fig. 399).

DANGEROUS EDGES

When plaster is cast into a boarded area, the plaster will invariably curve upward at the point where it meets the surface of each board. When the boards are removed, this edge is exposed as being knife-sharp and must be removed (Fig. 400). To do this, a straight-edged scraper is most generally used.

In scraping, there is a right way and a wrong way. The right way is to always scrape *toward* the flat plaster surface, *not* toward the sharp edge (Fig. 401). Whether you are scraping around an inner opening in the mold or around the outer edge of a mold, a rotary scraping motion toward the plaster surface only is recommended.

TRIMMING MOLDS AND BLOCKS

As we have seen, plaster can form sharp edges which can be as dangerous as a knife blade, and which — if left as such — would make handling molds a hazardous task. It is

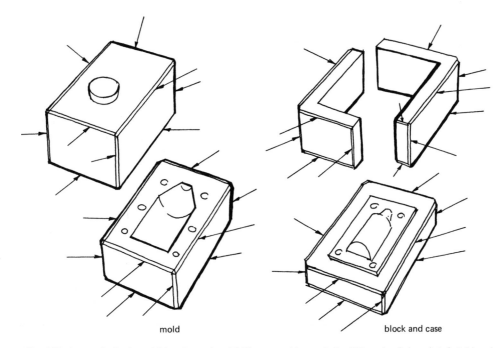

mold block and case

Fig. 402. Arrows indicate outside edges of mold. These are trimmed at a 45° angle of chamfer. Outside edges of blocks and cases are also trimmed in this way. No forming edges are ever trimmed.

for this reason that, in addition to scraping the edges flush, after casting has been completed, we trim the outside edges of all molds and blocks at a 45° angle of chamfer. This trim also eliminates any fraying and chipping along these edges.

Every exposed edge should be trimmed in this manner except those edges which come together to do the actual forming of the piece. A rough trim can be done with a knife when the mold is in the heat of crystallization and not quite hard. The finished trim is then done a few minutes later. It must be emphasized that the edges which come in contact with the liquid plaster, that is, the *forming* edges, are *not* to be trimmed. This, obviously, is to prevent creating a V-shaped leak in the mold (Fig. 402).

Note: Molds are *not* trimmed if they are to be subsequently used to make a model mold or to make blocks and cases.

WEIGHT-SAVING PRODUCTION MOLDS

Some molds, such as those for bottle shapes, lend themselves to saving weight and excess plaster by the elimina-

Fig. 403. One section of the untrimmed model mold shows how the corners are sawed off.

tion of two corners; sometimes even all four corners may be cut off (Fig. 403). This produces a mold that dries faster, weighs less, and is easier to handle. The model mold is made in the usual way with the outside walls having a rectangular configuration. The appropriate corners are then sawed off in order to make blocks and cases from which weight-saving production molds may be made.

139

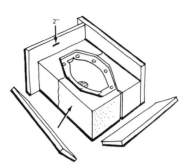

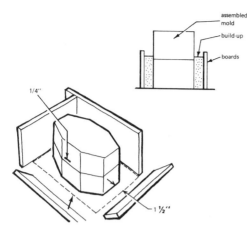

Fig. 404. Boards are put up at a distance of 1½ inches from the assembled mold to cast a build-up for making the blocks. Plaster is poured to a mark of ¼ of an inch above the mold's seam (the taller mold section is on the work surface) to produce the build-up.

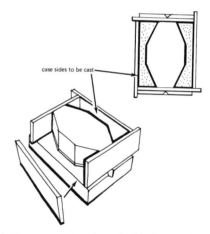

Fig. 405. The top section of the mold is removed. The build-up is fractured, soaped, and reassembled around the thicker mold section; the unit is then boarded for casting the first block. Ultracal 30 is poured to a mark 2 inches above the mold.

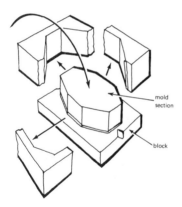

Fig. 406. The first block and its mold section are inverted and the build-up is removed.

Fig. 407. Boards are placed on the block at each end and flush against the block at each side to cast two case members simultaneously. Plaster is poured to ⅛ of an inch above the mold and screeded flush with its top surface.

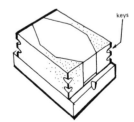

Fig. 408. Casting boards are removed. Keys are cut on each corner of the two case members.

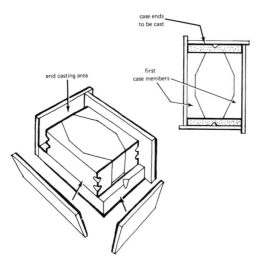

Fig. 409. Boards are placed around the combined form of the block, first case members, and mold section, to cast two end case members.

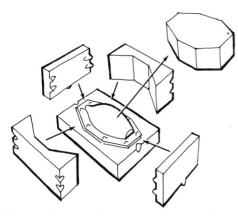

Fig. 410. Exploded view of the completed block and case with its corresponding mold section removed. The second block and its case members are made in the same way as the first, except that the build-up is inverted to fit properly and the thinner mold section is raised with shimming blocks so its top surface is only ¼ of an inch below that of the build-up. When reassembled, the blocks and cases will produce the weight-saving production mold.

PATCHING

All plaster casts are subject to the formation of small pits due to air bubbles and the formation of small bumps due to surface irregularities on the original model. Bumps may be removed by careful scraping and sandpapering; holes or pits may be filled with a plaster patch which is then scraped smooth.

When mixing plaster for such a small repair, simply take a suitable quantity of plaster, such as a teaspoonful, and mix it with a little water to achieve a thick, creamy consistency. This can be done on the work surface or in the palm of your hand, using a spatula to work the mix back and forth. Wet the pitted area with a few drops of water. Then, using the spatula or a small plaster-modeling tool deposit a small amount of the mix into the hole, letting it mound up above the surface.

After applying the mix to the hole, add another few drops of water over the patch. This and the previous wetting keeps the original cast from absorbing moisture too rapidly from the patch, which would then lose its proper strength. When the plaster patch is dry, carefully scrape the mounded area flush with the surrounding surface. Sandpaper as necessary.

If the need arises to fill a larger hole, such as might be caused by a change in the design of a mold or in the elimination of an extra opening, it is necessary to *soap* the inside of the cavity to be filled. This seals the plaster so that, once again, the surrounding plaster does not draw off the water too rapidly from the plaster patch. Expansion within the hole keeps the repair from coming out.

REINFORCING

As more experience is gained in dealing with molds, one soon comes to realize that certain configurations are subject to breakage or partial fracturing, especially due to the expansion of the material. In cases such as these, this problem can be anticipated and usually prevented by the use of metal reinforcement.

The most commonly used reinforcements are iron rod, wire, and mesh. Any or all of these are used depending on the nature and scale of the piece. Jute webbing is often used in the free-form molds produced by the metal shim and clay fence methods of blocking off the model. In these methods, commonly used by sculptors, the mold sections are built up in layers of applied plaster (see page 134). The jute is usually cut into strips, dipped in wet plaster, and applied to the mold in progress, becoming an integral part of the mold.

Fig. 411. Wooden sticks can be tied into the plaster mold sections with plaster-soaked jute for reinforcement and to provide handles.

Fig. 414. Store thin sections of plaster vertically to prevent warping.

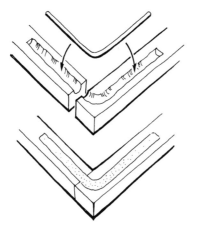

Fig. 412. Metal rods or wires can be used for reinforcement and to join pieces of plaster.

Fig. 415. Weight plaster to counter curvature if it has warped.

Fig. 413. Use wire mesh to reinforce projecting parts of plaster.

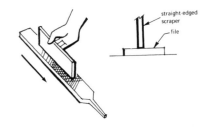

Fig. 416. Keep straight-edged scrapers sharp by filing.

142

For free-form molds as well as rectangular molds of poured plaster, wooden sticks can be combined with jute dipped in plaster. These can be used to provide exterior reinforcement by tying-in the ends of the sticks with a webbing of jute. They can also serve as convenient handles when elevated as they are tied in (Fig. 411).

Metal rods and wire can be preformed before casting and either laid in position before the cast is made or placed in the wet plaster as it is setting up. It is sometimes necessary, especially when joining plaster sections, to carve out channels in already cast pieces to accommodate the wire reinforcement and then lay plaster over the wire (Fig. 412).

In making molds, especially in making blocks, one often encounters forms that require parts to project from the bulk of the piece. Expansion of plaster between two such projections may crack one or both of them. Before such a piece is cast, note the location of each projection and mark it by drawing co-ordinate lines opposite each other on the top edge of the mold (Fig. 413). Measure the depth of each projection and cut a piece of mesh for each one just short of the measured depth. Once cut so that it will fit vertically in the projection, the mesh can be placed in the mold, after the plaster has been poured, by lining it up with the co-ordinate marks and, with a minimum amount of groping, dropping it into place. Such preventive measures are usually successful in saving much repairing and recasting of molds.

STORAGE AND WARPING OF PLASTER PIECES

Believe it or not, plaster bends. When storing relatively thin pieces, it is best to place them on end vertically to keep them from warping (Fig. 414). If a section of mold has warped, it can often be brought back to true alignment by placing weight on it, to counter the curvature, and letting it sit until flattened (Fig. 415). Never store narrow mold sections at an angle or flat on uneven surfaces, for they will flex and follow the contour of the surface.

CARVING

Although we have indicated the use of templates wherever possible because they tend to give greater control over a piece, we by no means wish to imply that hand-carving is not to be considered as a forming technique. Often it will be a combination of the two that will serve best.

ON SHARPENING TOOLS

The traditional methods of sharpening tools used for scraping or cutting hold for plaster tools as well. Files, finishing stones, and grinding wheels are all needed to keep tools sharp, and they should be used often.

It might be noted that since straight-edged scrapers occupy a place of real importance in one's kit, they are to be kept sharp by placing the cutting edge against the flat face of a file and moving the tool back and forth in the long direction (Fig. 416). This method holds true for any piece of metal that you wish to have a straight and even edge.

On the subject of tools in general, we would like to remind you that there are few limitations as to what will serve as a plaster-working tool — anything that has an edge or a surface that will cut or abrade plaster will do, whether it be a piece of hacksaw blade or a dental probe.

This also holds true for materials used for finishing. Any abrasive material can be used — one need only experiment to build a good working "vocabulary" of finishing techniques, using everything from sandpaper to steel wool, and even facial tissues.

IN CONCLUSION

What has been described within this book represents many hours of actual practice, and it is only with actual practice and accumulated experience that proficiency will come. As you gain mastery of the material, you will find an ever-rewarding satisfaction in working with it.

Index

air bubbles, 14, 24, 25, 141
air, compressed, 136
angle of withdrawal, 27-37, 40-41, 48, 64, 82-84, 86, 91-92, 134
appendage removal, 37, 85

bench turning, 115-116
block and case, 62, 64, 80, 136
blocking off, 38-39; *also see* clay build-up, plaster build-up
blocks, 62, 70-76, 139-141
 build-up for, 70-71, 74-75, 140

boarding the form
 for blocks and cases, 70, 72-74, 76-81, 140-141
 for molds, 42-44, 47, 58, 61, 68-70, 86, 132
 for running plaster, 97-98
box forms, 16-19
box turning, 106-107

carving, 121, 143
cases, 62, 77-81, 140-141
 build-up for, 77
casting sequence, 85-87, 88, 89, 91, 92-94
clamps, 18, 19
clay, 14
clay build-up, 38, 41, 47, 48, 64, 67, 85, 86, 91, 92, 93
clay walls, 51-54, 130, 134
claying seams, 16, 17, 18, 42, 58, 68, 70, 98, 102, 103, 111
coddles, 16, 17, 102-103, 109-112, 114, 119, 121, 123
consistency number, 10, 22, 23
cross-section drawings, 82-84, 92

dangerous edges, 138
draft, 26, 27, 29, 30, 31, 33, 37, 48, 66
drill scraping, 115

expansion of plaster, 9, 25, 26, 136, 137, 141
extruding plaster, 95-99, 123-128

forming wet plaster, *see* drill scraping, extruding, hand scraping, turning
fracturing
 the build-up, 71, 74-75
 the mold section, 136-137

gypsum, 9, 12

hand scraping, 114-115, 130

jack, 95-99, 114, 115-116, 125-127

keys, 43-44, 88

lathe turning, 107-113
linoleum, 14, 16-17, 20, 131-132
locking principle, 88-90

mixing, 10-11, 22-24
 supplies, 13, 14
model, the
 analyzing, 26-37, 64-65, 82-93
 cast from waste mold, 135
 removing from mold, 136-137
 removing parts from, 37, 85
 also see positioning
model-making, examples 117-133
 techniques, 95-116
models, porous, 21
mold intersections, 85
molds
 casting techniques, 38-61, 64-70
 constructing, 118, 131, 133
 trimming, 138-139
 also see blocks, cases, draft, locking principle, parting lines, positioning the model, shim mold, undercuts
molds, types
 model, 62-71, 135-136, 139
 multi-piece, 32-37, 38-39, 82-94
 one-piece, 27, 120
 production, 62, 136, 139, 141
 two-piece, 27-32
 waste, 134-136
 weight-saving, 139-141
 also see blocks, cases

negative space, principle of, 117-133

oil separator, 21, 98

parting lines, 28-37, 47-49, 64-66, 86, 90, 91-92
patching, 141
plaster
 hardness of, 10, 11, 25
 measuring, 22-23
 mixing, 10-11, 22-24
 pouring, 25
 properties of, 9-12
plaster build-up
 for blocks and cases, 70-71, 74-75, 77
 for molds, 38, 49-54
 for turning plaster, 101-104, 119-123
plaster-turning tools, 15, 102
plaster-wheel turning, 100-104, 119-123, 132
plasticity, 10
plumb-bob, 30

plywood boards, 14, 16, 18, 20
positioning the model
 for casting the mold section, 31-32, 38-41, 47-48, 49, 55-56, 65, 86, 92
 for the parting line, 29-34, 40, 64-66

reinforcing plaster, 141-143
removing the model, 136-137
retaining walls, 16-19
 supplies, 14
running a section, 99

sawing, 71, 74-75, 127, 136, 137
screeding, 25
separators, *see* oil, soaping
setting time 10, 11
sharpening tools, 143
sheet metal, 15
shim mold method, 134-135, 136
slaking, 24
soap, 14
soaping, 20-21
spares, 46-47, 56, 59-61, 65, 66, 69-70, 75, 87, 88, 89, 91, 92, 93, 94, 138
storage
 of clay, 14
 of dry plaster, 11
 of molds, 143
surface gauge, 15, 49

template,
 metal, 96-97, 98, 99, 102-104, 105, 106, 114-116, 119-123, 124-127
 plaster, 130-132
trimming, 138-139
turning plaster
 by rotating plaster, 100-113
 by rotating template, 113-116
turntable turning, 105

undercuts, 27-31, 33, 37, 66

volume
 of water needed, 22
 converted to weight, 23

warping, 142, 143
waste molds 134-136
water-to-plaster ratio, 10-11, 22-23
weighing plaster, 11, 22-23
withdrawal, basic directions of, 34; *also see* angle of withdrawal, draft
work area, 13-14
work surface, 14
working drawings, 101, 108, 119. 120 121. 122, 124, 128, 129; *also see* cross-section drawings